POSTCARD HISTORY SERIES

New London

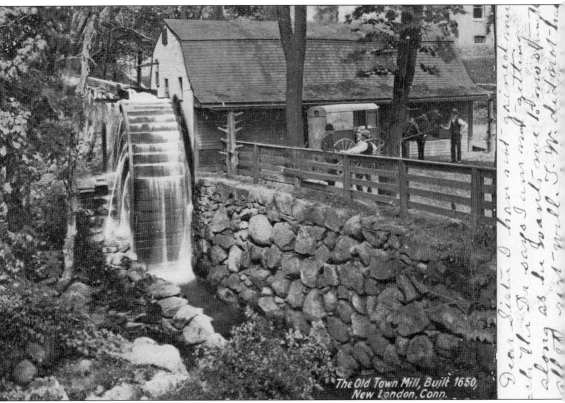

The Old Town Mill, Built 1650,
New London, Conn.

This postcard shows the Old Town Mill, located on Mill Street just off State Pier Road and under the Gold Star Memorial Bridge. The mill was listed in the National Register of Historic Places in 1982 as "Winthrop Mill." In 1650, town founder John Winthrop, Jr. ("The Younger") paid men to prepare a pond (not shown) and build the mill. At that time, no other person was allowed to build a competing mill within the city limits. According to the plaque at the mill, it is one of Connecticut's earliest industrial sites. Throughout the Colonial period, this mill was used to grind flour from wheat, corn, and rye. The mill was rebuilt many times, including during the recovery period after Benedict Arnold's raid on New London. This happens to be one of the few remaining mills from that era. When Winthrop was elected governor, he had to relocate to Hartford, so he leased the mill to a baker named Mr. Rogers, who erected a stone house and bakery at the site around 1658. On this postcard, the Winthrop School, which is no longer standing, is visible behind the mill. (Courtesy of the authors.)

ON THE FRONT COVER: The populace of New London surrounds the Soldiers and Sailors Monument around 1905. (Courtesy of the authors.)

ON THE BACK COVER: Ocean Beach, shown here in the 1950s, has long been a draw for crowds and a destination for visitors from all over New England. (Courtesy of the authors.)

POSTCARD HISTORY SERIES

New London

Lawrence Keating and Catherine Keating
Introduction by Paul Foley and Timothy F. Foley

ARCADIA
PUBLISHING

Published by Arcadia Publishing
Charleston, South Carolina

Printed in the United States of America

Library of Congress Control Number: 2014959797

For all general information contact Arcadia Publishing at:
Telephone 843-853-2070
Fax 843-853-0044
E-mail sales@arcadiapublishing.com
For customer service and orders:
Toll-Free 1-888-313-2665

Visit us on the Internet at www.arcadiapublishing.com

To Our Whaling City, New London, Connecticut
God Bless America!

CONTENTS

ACKNOWLEDGMENTS

All of the postcard images in this book were chosen from the personal collections of the authors, unless otherwise noted as being from personal collections of friends of the authors. This compilation and the historical captions could not have been possible without help and cooperation from each other and others. We thank Ann Marie Keating, Paul Foley, Timothy Foley, Mary Keating, David Morrison, James and Angela Murray, Marcia Stuart, Rick Gipstein, Albert Glassenberg, Lawrence M. Keating, and New London city historian Sally Ryan.

Information was verified and/or obtained from the following sources, and we thank and acknowledge them: New London Landmarks; New London County Historical Society; New London Public Library; Fishers Island Ferry District; Thames Shipyard; Mitchell College; *The Day* newspaper; Images of America: *Mystic*, by the Mystic River Historical Society; National Park Service; US Department of the Interior; Friends of Fort Trumbull; US Coast Guard Academy; Lyman Allyn Art Museum; Connecticut College; New London Maritime Society; eOneill.com; "Sacred Spaces" brochure by New London Landmarks; New London Cemetery Association; Report of the State Board of Charities; State of Connecticut Judicial Branch; Carol W. Kimball; Ledge Lighthouse Foundation; *The Whaling City: A History of New London*, by Robert Owen Decker; *History of New London, Connecticut: From the First Survey of the Coast in 1612 to 1860*, by Frances Manwaring Caulkins; and New London "City Directories."

Many of the locations pictured in this book are listed in the National Register of Historic Places, and we would like to mention them here: Bulkeley School; Coit Street Historic District: Brewer, Blinman, Coit and Washington Streets; Deshon-Allyn House; Downtown New London Historic District: roughly bounded by Captain's Walk, Bank, Tilley and Washington Streets, along Huntington, Washington and Jay Streets, southwest corner of Meridian and Gov. Winthrop Boulevard, along Bank and Sparyard Streets; Fort Trumbull, Jonathan Newton Harris House; Hempstead Historic District; Lighthouse Inn; Montauk Avenue Historic District: roughly bounded by Ocean, Willets and Riverview Avenues and Faire Harbour; Monte Cristo Cottage; New London County Courthouse; New London Custom House; New London Harbor and Ledge Lighthouses; New London Public Library; New London Railroad Station (Union Station); Ohev Sholem Synagogue; Pequot Colony Historic District: roughly bounded by Gardner, Pequot, Glenwood, and Montauk Avenues; Post Hill Historic District: Addison Street, Amity Street, Berkeley Avenue, Broad Street, Center Street, Channing Street, Cleveland Street, Fremont Street, Granite Street, Hempstead Street, Nathan Hale Street, Post Hill Place, Summit Avenue, Vauxhall Street, West Street, and Williams Street; Prospect Street Historic District: roughly bounded by Bulkeley Place, Huntington, Federal, and Hempstead Streets; Shaw Mansion; St. James' Episcopal Church; Civic Institutions Historic District: Colman Street, Garfield Avenue, Walden Avenue; Thames Shipyard (Historic American Engineering Record); United States Housing Corporation Historic District: roughly bounded by Colman, Fuller, and West Pleasant Streets, and Jefferson Avenue; US Post Office; Whale Oil Row: 105-119 Huntington Street; Williams Memorial Institute (WMI); Williams Memorial Park Historic District: Williams Memorial Park Historic District; Winthrop Mill

INTRODUCTION

"The Whaling City" of New London, founded in 1646, has always been an important part of the development of southeastern Connecticut. Its harbor at the mouth of the Thames River naturally turned New London to the sea. Its location, halfway between New York and Boston, has been advantageous.

The second half of the 19th century and the first half of the 20th century saw the cities of America—both large and small—experience unpredictable expansion. The United States was fast becoming a leader in the industrial world; before long, it would be a world power.

By 1850, New London was already a thriving city. It was considered one of the world's whaling capitals; as such, fortunes were made by whaling ship captains, as well as the mercantile class, which supplied ships with necessary supplies for long expeditions. The city flourished as an industrial center, shipbuilding base, and whaling port. At the time, the whaling industry was at its peak, and many New London families became very wealthy as a result.

Ideally located on a relatively sheltered deepwater harbor, the city became a center of boatbuilding and shipping. Railroads soon followed, and industrial growth expanded rapidly. Factories were built, offering employment to thousands of immigrants who had come from Eastern Europe, Russia, Italy, Ireland, and other distant lands.

The immigrants came with the hope of a better life for themselves and their families. They brought many of their traditions, some of which continue to this day. These men and women were responsible for the construction of most of New London's churches and houses of worship.

New London also had a booming industrial base. Factories for firms such as Brainard & Armstrong, which produced silk, and Boss Cracker (located at 77 Potter Street), which produced crackers, were known throughout America. A wealthy class of New Londoners emerged, including families such as the Learneds, Lymans, Newcombs, and Lawrences. As the whaling industry declined worldwide, New London, already the hub of southeastern Connecticut, evolved to meet the needs of a growing community.

The middle of the 19th century and the early part of the 20th century was New London's greatest era. A summer resort, the Pequot Colony, developed in the southern part of the city; its residents and guests rivaled Newport in its day. Wealthy families, many from Philadelphia and Pittsburgh, came to summer in what was regarded as the "second Newport." Families such as the Rayburns, Guthries, Tiffanys, Cartiers, Sacketts, and Rhinelanders had summer estates in New London. Additionally, until almost 1900, the staff of some 90 embassies came to New London to escape the oppressive heat in Washington, DC.

New London has seen a great many changes due to three major episodes: the 1938 hurricane, indiscriminate redevelopment during the 1960s and 1970s under the Federal Urban Renewal Program, and the expansion of Interstate 95 and the Gold Star Memorial Bridge. The heart of the city was destroyed by these events and by the 15-year ban on motor vehicles on State Street. Fortunately, the best of New London is presented to readers within this collection of postcards and photographs.

—Paul Foley and Timothy F. Foley
Lifelong residents, career bankers, and active volunteers for organizations in New London

INDEX

One

DOWNTOWN AREA

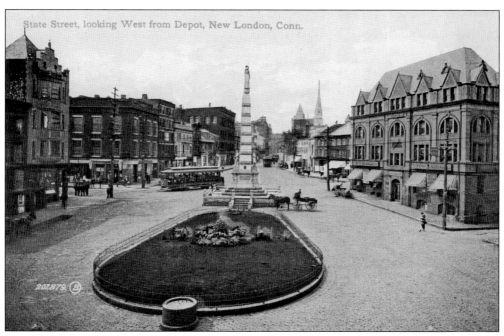

State Street, looking West from Depot, New London, Conn.

This c. 1910 view of State Street looks west from the Thames River and the railroad station and into the main thoroughfare of downtown. The Soldiers and Sailors Monument, at the center, has a small circular parklet next to it that contains a fountain and two cannons. It also has a watering trough (visible at the bottom of the image).

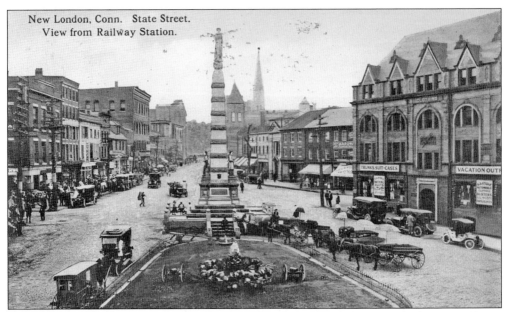

New London, Conn. State Street.
View from Railway Station.

This 50-foot-tall statue, a gift to the city from Sebastian D. Lawrence, is a tribute to military veterans. It was erected in May 1896 and is referred to as the Soldiers and Sailors Monument. At the top is a nine-foot-tall female figure called "Peace," and the two seven-foot-tall figures at the base represent a soldier and a sailor.

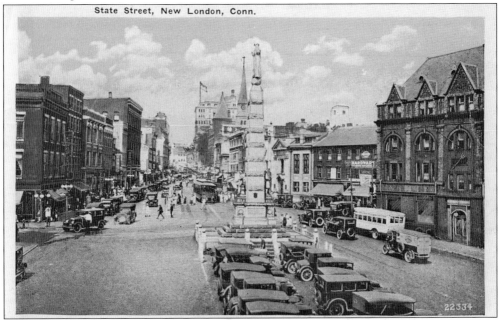

State Street, New London, Conn.

This section of State Street is called the Parade, because the military (home defense guard) that existed when New London was established may have used this area for marching and drilling. A courthouse and an Episcopalian church were located at right and at center, respectively, until they were burned during Benedict Arnold's raid on September 6, 1781, resulting in an abandoned burial site that was once adjacent to the church. Note that this early-1920s postcard illustrates the removal of the parklet, which was replaced with parking spaces.

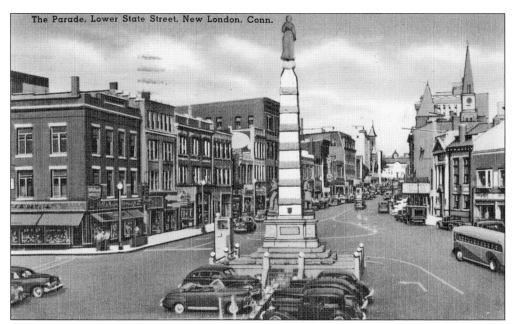

The Parade, Lower State Street, New London, Conn.

This west-facing view shows State Street in the late 1930s or early 1940s. Note the two police traffic booths, one facing Bank Street (background) and one facing Main Street (center). Right of center is the overhanging marquee of the Victory Theatre, as well as the pillars of one of the oldest banks in Connecticut, the Union Bank. Also at right are the clock steeple of the First Congregational Church and the pyramid-shaped roof of the Harris Building. The courthouse is visible in the distance. Note the changes in automobile styles from the previous postcard.

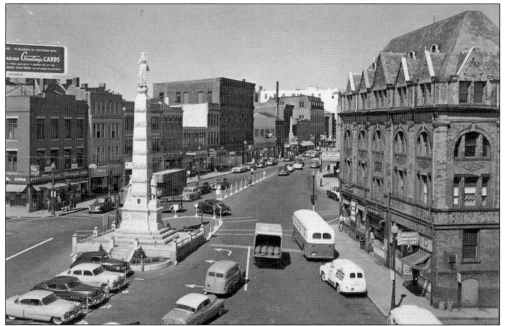

The large building at right, known as the Neptune Building, was once owned by the Salvation Army and was demolished in 1967 during redevelopment. Note the traffic dividers, the absence of police boxes, and the continuing changes in automobile styles shown on this c. 1953 postcard.

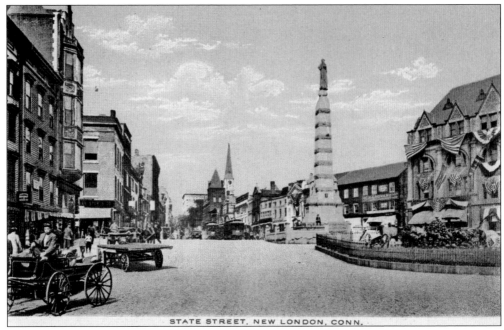

STATE STREET, NEW LONDON, CONN.

The Parade, at the foot of State Street, has always been the center of activity in downtown New London. The Mohican Hotel, visible in the distance at right, is shown prior to the 1916 construction of its top three floors. At left is the "cube building," with its windows protruding over the sidewalk.

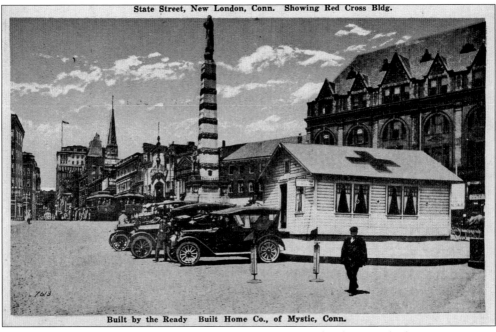

State Street, New London, Conn. Showing Red Cross Bldg.

Built by the Ready Built Home Co., of Mystic, Conn.

This postcard shows the east end of State Street. Taxis wait for the arrival of trains. At center is the Soldiers and Sailors Monument. In the distance, two trolleys load and unload passengers. Note that the top three floors of the Mohican Hotel are in place. The large structure on the right is the Neptune Building.

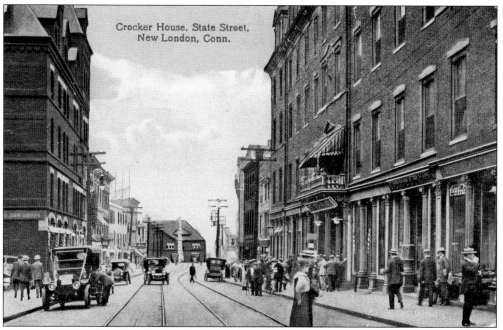

Crocker House, State Street, New London, Conn.

This view looks down State Street toward Union Station. The large building at right is the Crocker House, a leading hotel in downtown New London for many years, which opened in 1873. Note the social veranda and its spectators on the street. This postcard shows trolley tracks, which were laid beginning around 1892 at a rate of about one mile per week. The tracks throughout New London were still being removed in the 1950s.

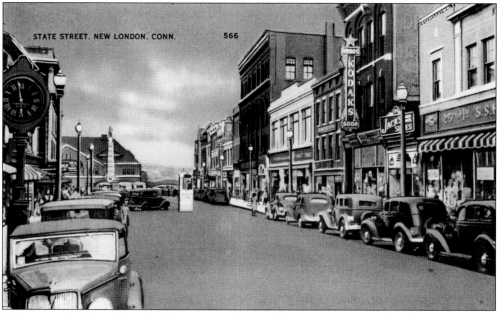

STATE STREET, NEW LONDON, CONN. 566

This postcard of State Street looks east toward Union Station. At center is the white police booth used for directing automobile traffic at Main Street (now called Eugene O'Neill Drive) and State Street. The booth remained in this location into the 1950s. Note the clock at far left and how individual lampposts have taken the place of utility poles and overhead wiring.

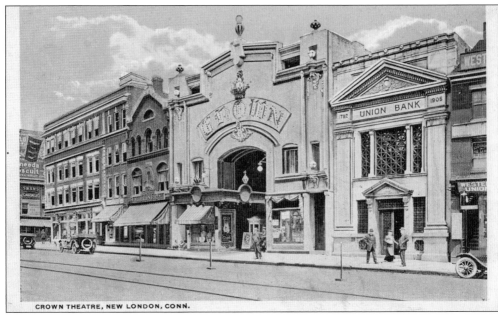

This image of lower State Street shows Union Bank and the Crown Theatre (built in 1914), which eventually became the Victory Theatre. The Union Bank was chartered in 1792 by the State of Connecticut. In the 20th century, it became Connecticut Bank & Trust; it folded in 1991. This entire area, demolished in the 1960s as part of New London's redevelopment program, is now occupied by Union Plaza.

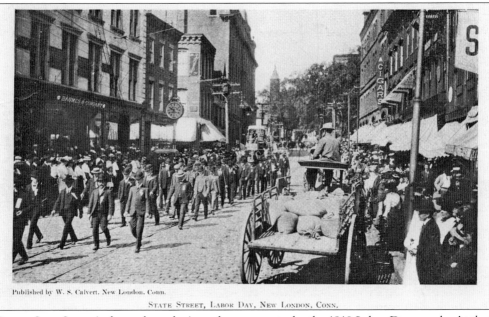

Published by W. S. Calvert. New London. Conn.

STATE STREET, LABOR DAY, NEW LONDON, CONN.

Lower State Street is shown here during what appears to be the 1910 Labor Day parade. At that time, this area was commercially developed and very busy; meanwhile, parts of upper State Street were still residential. Note the location of the clock at left. Beyond the awnings at left is the building that once housed Timothy Green's print shop—it was erected around 1771 and is the oldest structure on the street. (Courtesy of David Morrison.)

14

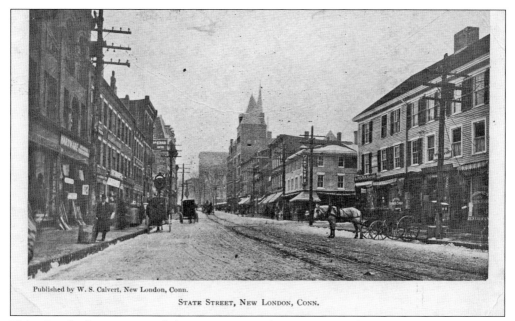

Published by W. S. Calvert, New London, Conn.

STATE STREET, NEW LONDON, CONN.

This view looks west toward the intersection of State Street and Main Street (now Eugene O'Neill Drive). The site of the three-story building at right, located at the corner of State and Main Streets, is now occupied by the Union Plaza building. (Courtesy of David Morrison.)

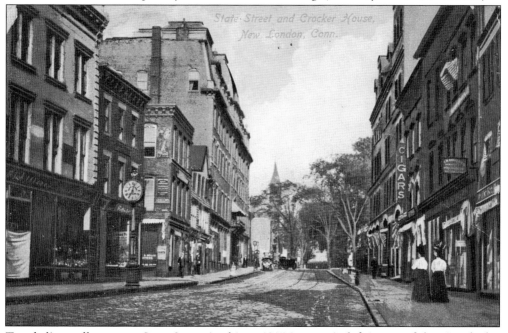

Two ladies walk west on State Street in this c. 1915 image. At left is one of the city clocks, which had been relocated about three times. The building at 128 State Street, Bacon's Marble Block (near left), was constructed around 1868. The building beyond the clock was erected in 1873. The large building at left with the slanted fifth floor is the Crocker House. The steeple of the Baptist church is visible in the distance. Note the trees along the street and the absence of utility poles.

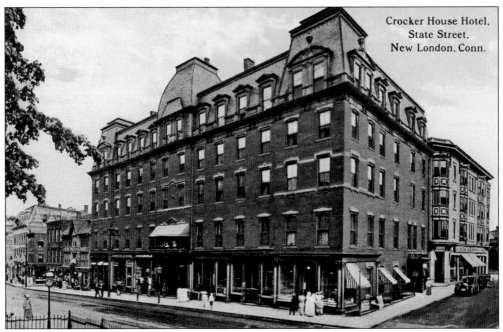

The Crocker House, located on the corner of State and Union Streets, opened on New Year's Eve in 1873. The first operating manager was Henry Crocker, who also managed the Pequot House Hotel. This is now an apartment building. The location within the area at the lower right corner of the Crocker House was where Nathan Hale taught in a schoolhouse from 1774 to 1775.

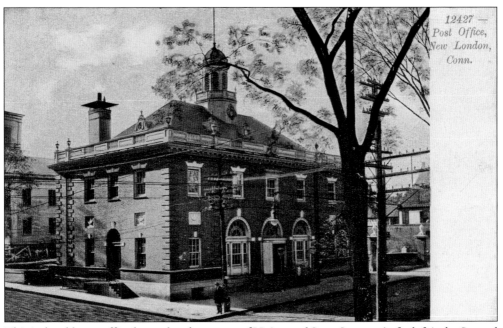

This is the old post office located at the corner of Union and State Streets. At far left is the Second Baptist Church, organized in 1840 (see page 107); the church was dismantled around 1905, and the pews were given to New London's first synagogue (Ahavath Chesed) which was located at 8 Shapley Street. Around 1906, additional space was added to the back of the post office.

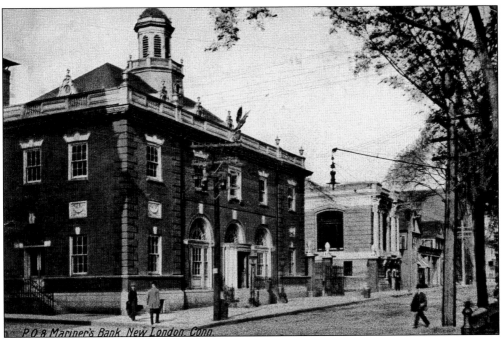

The old post office stood at the corner of Union and State Streets. The site, later the home of Montgomery Ward, is now occupied by Frontier Communications. In this postcard, Mariners Savings Bank is next to the old post office.

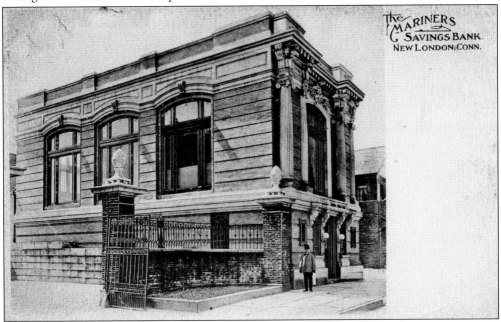

Mariners Savings Bank, located on State Street, was constructed around 1906. Merchants connected to the whaling industry founded the bank in 1867. The bank contained many items connected with the whaling industry, and its office was like a museum. It folded in 1939 and was taken over by the Savings Bank of New London. The whaling memorabilia was entrusted to the Mystic Seaport Museum.

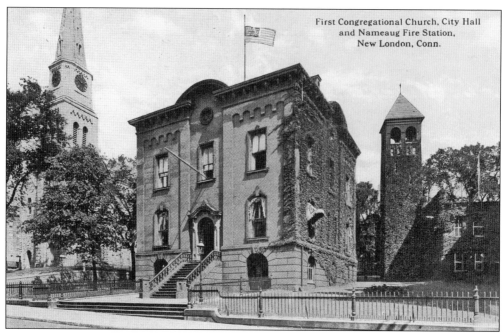

First Congregational Church, City Hall
and Nameaug Fire Station,
New London, Conn.

New London City Hall, on State Street, was built in 1856 and completely renovated in 1912 to its current appearance. At left is the First Congregational Church, built in 1850 (see page 105). The Nameaug fire station (right) was demolished in the city redevelopment of the 1960s. The Nameaug fire station was previously located on Main Street (more information can be found in *New London Firefighting*, by Tara Samul).

Municipal Building, New London, Conn.

New London City Hall, located at 181 State Street, is shown as it looks today. The Old Ladies' Home is behind it at left. The Harris Building (at right), constructed in 1885, is named for Jonathan Newton Harris, who made his fortune in patent medicine.

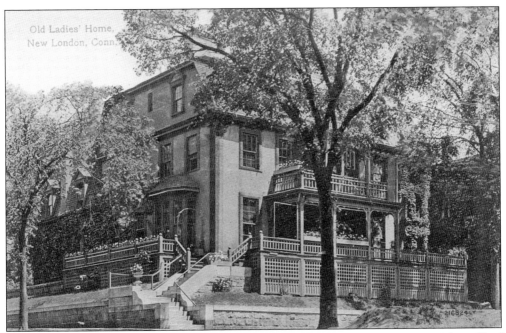

The Old Ladies' Home was located at the corner of Masonic and Union Streets. The will of Dr. Seth Smith provided for this building, along with funds for maintenance and for the care of women 65 years of age and older. It opened before 1890, and it was relocated to Vauxhall and Williams Streets and was renamed Smith Memorial Home around 1930. The home shown here was demolished, and the post office now occupies this site.

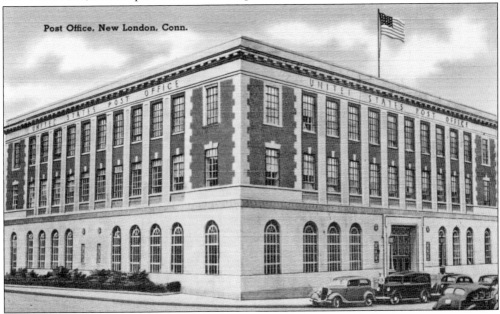

This post office, built by local architects Morris Payne and Ed Keefe in 1933, occupied 27 Masonic Street after the relocation of the Old Ladies' Home. The lobby's famous murals, painted by Thomas Sergeant LaFarge, reflect life on a whaling ship. The building was added to the National Register of Historic Places in 1986.

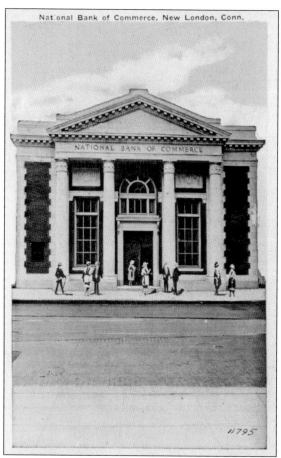

National Bank of Commerce, New London, Conn.

The National Bank of Commerce, a leading commercial bank in New London in the early 20th century, built this office on State Street in 1922. In 1953, it merged with Hartford National Bank & Trust Company. Later mergers changed the name of the bank to Connecticut National Bank, Shawmut National Bank, Fleet Bank, and, finally, Bank of America. In 2013, Bank of America closed this bank and sold the property to the nearby Baptist church, the Church of the City, New London.

The National Bank of Commerce replaced this YWCA house in 1922. The YWCA was eventually relocated to 93 Huntington Street; that building was demolished during redevelopment in the 1960s. At right is First Baptist Church.

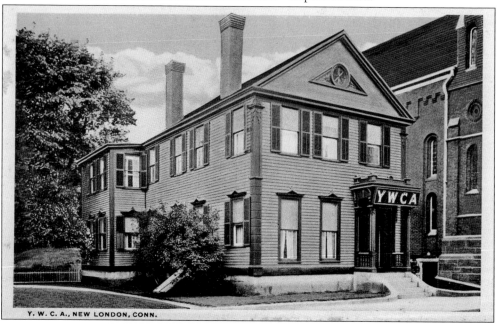

Y. W. C. A., NEW LONDON, CONN.

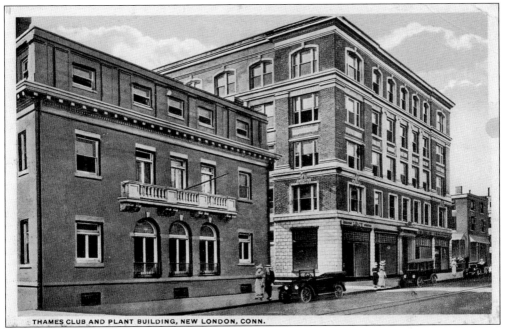

THAMES CLUB AND PLANT BUILDING, NEW LONDON, CONN.

The Thames Club (left), located at the corner of State and Washington Streets, was founded in 1869 and is rumored to be Connecticut's oldest social club. This building replaced the original structure, which was destroyed by fire in 1904. The five-story Plant Building (right) was erected in 1915 by Morton F. Plant, a wealthy man who had a large estate in Groton, Connecticut. It is now known as the Dewart Building.

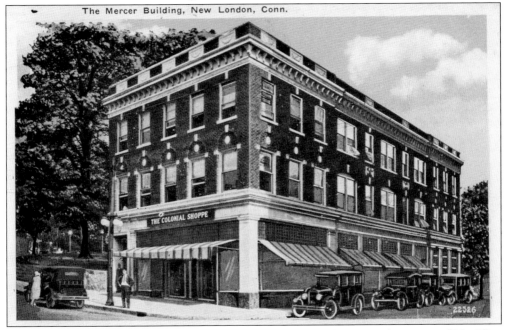

The Mercer Building, New London, Conn.

This postcard shows the Mercer Building, located at 309 State Street on the corner of Meridian Street. It was built around 1926 on land from the Thomas Williams estate and is now part of the Garde Arts Center.

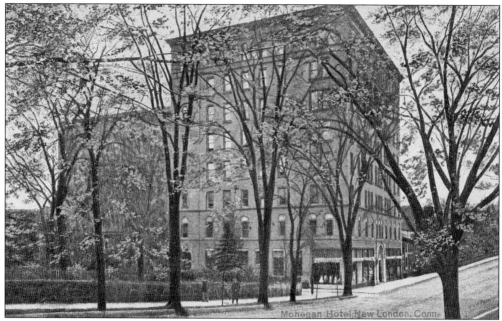

The Mohican Hotel, located at 281 State Street, east of Meridian Street, was the tallest building in New London when it was erected in 1895–1896. The owner, Frank A. Munsey, originally constructed it to house publishing operations, but labor difficulties led to him ceasing those operations. He remodeled the building and changed it into one of the best hotels in New England. In 1916, he added three additional floors; the 11th floor was designated as a ballroom. This building now houses the Mohican Senior Apartments.

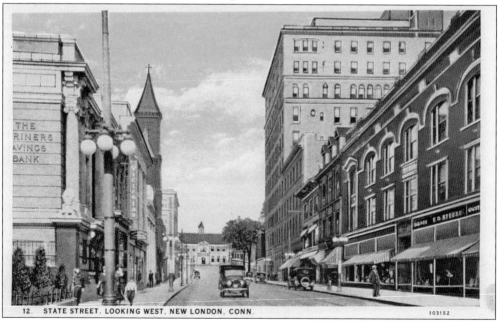

12. STATE STREET, LOOKING WEST, NEW LONDON, CONN. 103152

This postcard shows the buildings on the upper part of State Street, which was dominated by the Mohican Hotel. The Mariners Savings Bank is at left. The building at 223 State Street (far right), erected in 1913, is known as the Manwaring Building; it housed ladies' clothing stores.

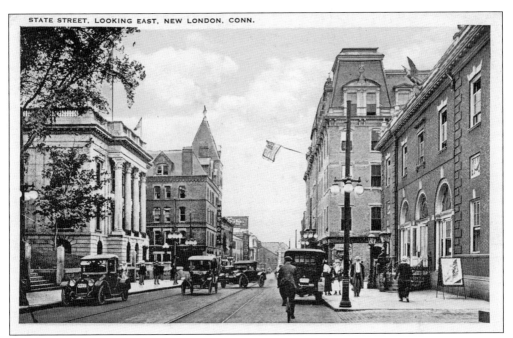

This 1910 view of State Street faces three important buildings in downtown New London. At right is the Crocker House (with the protruding US flag) and the old post office building; at left is the New London City Hall.

State Street was converted into a pedestrian mall in 1973 and 1974. In the 1970s, the name of the street was changed to Captain's Walk. The mall was unsuccessful, and the road reopened to traffic around 1990 under the name "State Street." (Photograph for this postcard by Rick Gipstein.)

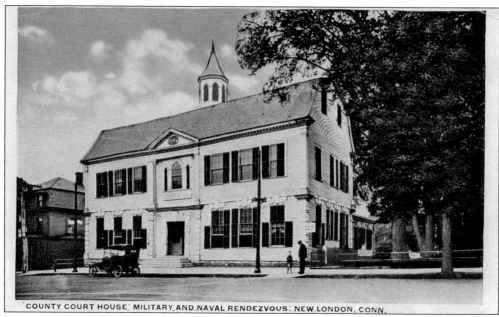

The State of Connecticut Superior Court, the oldest courthouse in the state, is located at 70 Huntington Street at the top of State Street, was built in 1784, and has been in continuous use since that time. This structure was moved back during the realignment of Huntington Street around 1839. The hip-roof house at left was the dwelling of Fredrick W. Mercer, president of New England Carpet Lining Company; in the 1950s and 1960s, it housed Shafner's Furniture Store.

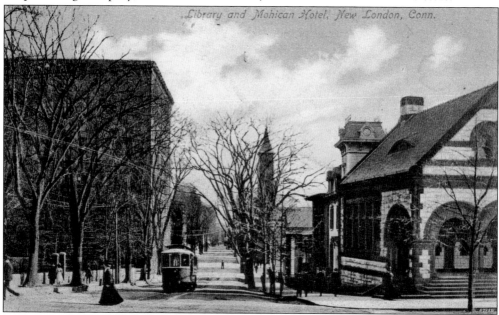

This c. 1900 postcard reflects the top of State Street, where it intersects with Huntington Street. The building at near right is the New London Public Library, which was listed in the National Register of Historic Places in 1970. At left is the Mohican Hotel. Today, the Garde Arts Center occupies the area filled with trees at near left; at the time, the land was part of the Thomas Williams estate.

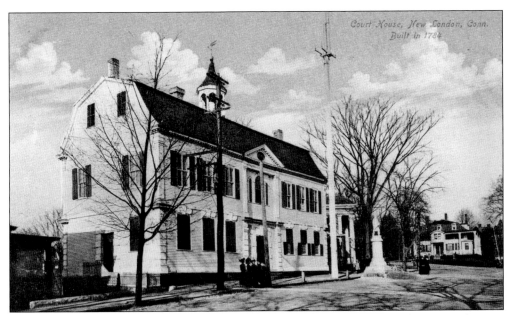

The State of Connecticut Superior Court, listed in the National Register of Historic Places in 1970, is pictured here with the liberty pole, which originally stood at the Parade on lower State Street. (The pole has been moved several times.) The Firemen's Monument (right of center) was given to the city by Sebastian D. Lawrence and has been moved at least twice (see page 126). At far right is one of New London's most famous homes, the Mount Vernon House.

This c. 1906 postcard shows the corner of Broad and Huntington Streets. At right is the Mount Vernon House, built in 1796 for Gen. Jedediah Huntington and named after Gen. George Washington's home in Virginia. The Mount Vernon House was razed in the late 1940s, but the front door of the house was saved and is now in the care of the Lyman Allyn Art Museum. The building with the columns at left was home to Walter Learned. The boy on the bicycle is New London native Herbert A. Haney, who had just finished delivering newspapers (as identified by his son, Gerald Haney).

25

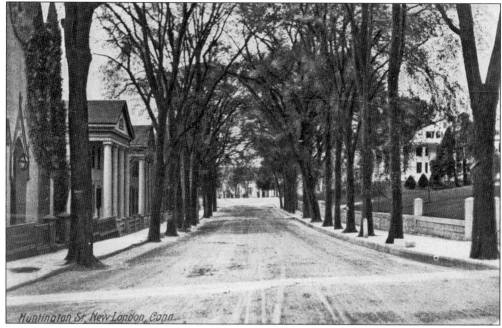

Huntington St. New London, Conn.

Trees line Huntington Street, as shown on this postcard that looks south toward State Street from the corner of Federal Street. Huntington Street was heavily lined with elm trees, many of which were destroyed in the hurricane of 1938. Barely visible at near left is St. James Episcopal Church alongside the Greek Revival houses of Whale Oil Row. At right is the Mount Vernon House.

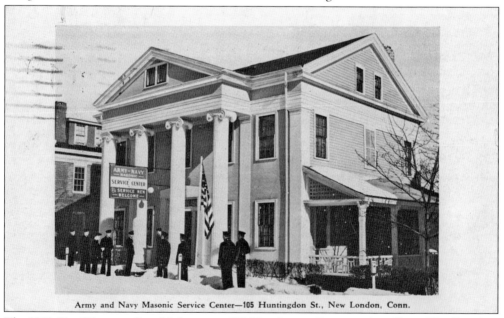

Army and Navy Masonic Service Center—105 Huntingdon St., New London, Conn.

The 1941 City Directory lists this house, at 105 Huntington Street, as the office of "Tall Cedars of Lebanon, New London Forest #72," (an apparent Masonic organization). The house, part of Whale Oil Row, was built on speculation around 1835 to sell to wealthy whaling agents. Dr. Carl Wies led efforts to save the buildings of Whale Oil Row (not all are shown) from being demolished by the city's redevelopment agency in the 1960s.

26

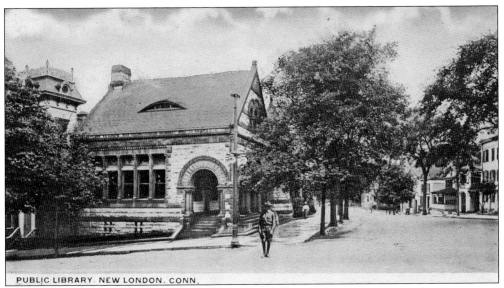

PUBLIC LIBRARY. NEW LONDON. CONN.

The New London Public Library, located at the corner of State and Huntington Streets, was built in the Richardsonian Romanesque style. Construction lasted from 1889 to 1892 and was completed by the architectural firm of Shepley, Rutan & Coolidge. The cost for building the library were paid by the estate funds of Henry Philemon Haven, a leading New London businessman. Although the library was recommended for demolition during redevelopment in the 1960s, it was spared. The tower at left was the last wooden structure demolished on State Street (around 1957), and the area is now a parking lot.

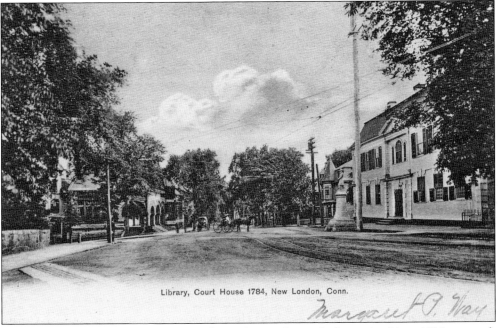

Library, Court House 1784, New London, Conn.

The top of State Street, at the corner of Huntington Street, is shown in this c. 1906 postcard. Note the absence of the St. Mary Star of the Sea Church tower/steeple, which was dedicated and partially built in 1876 but not completed until 1911. Also shown are the wall around the Thomas Williams property (at left), the liberty pole, and the Firemen's Monument.

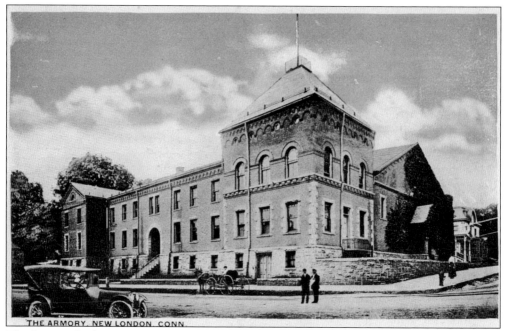

The Armory, built around 1885 on land purchased from the Coit family, was located at the corner of Coit and Washington Streets. It housed Infantry Company A and had an indoor basketball court and a shooting range. It was torn down in 1962, and a new armory was built on Bayonet Street in New London.

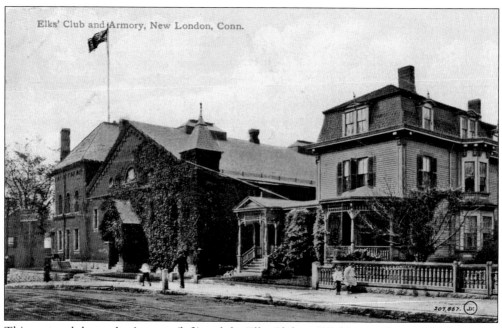

This postcard shows the Armory (left) and the Elks Club on Washington Street. The hurricane of 1938 destroyed a supporting wall of the Armory, which was torn down in 1962. Note the balustrade in front of the Elks Club.

28

ELKS CLUBHOUSE, NEW LONDON, CONN.

The Elks Club, located on Washington Street, was rebuilt as a brick structure in the late 1920s. The Southern New England Telephone (SNET) Company replaced the house at right in the mid-1920s. St. Mary Star of the Sea Church is visible in the background between them.

Southern New England Telephone Company operators are dressed for work in this c. 1939 image. The balustrade they lean upon is visible outside the SNET building as shown on page 28, but it is missing from the previous postcard. Female SNET operators had to be unmarried and arrived to work dressed "to the nines." The building in the background, at 59 Washington Street, was operated by Fishbone Brothers grocers in the 1940s and 1950s. This photograph appears courtesy of Mary Sullivan Carney (b. 1900), a former SNET telephone operator; she is not shown here.

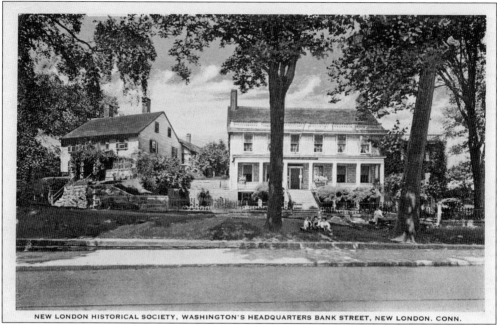

NEW LONDON HISTORICAL SOCIETY, WASHINGTON'S HEADQUARTERS BANK STREET, NEW LONDON. CONN.

The New London County Historical Society has been located in the Shaw Mansion, at 11 Blinman Street, since 1907. This former home of Capt. Nathaniel Shaw was built in 1756 using stone from the existing property. It served as Connecticut's naval war office during the American Revolution. During Benedict Arnold's 1781 attack, the pre-Revolutionary house at left was saved from fire by a soaking of vinegar. Locals referred to the owner as "Vinegar Joe" and the house as the "Pickle House"—it was razed for a parking lot in 1976.

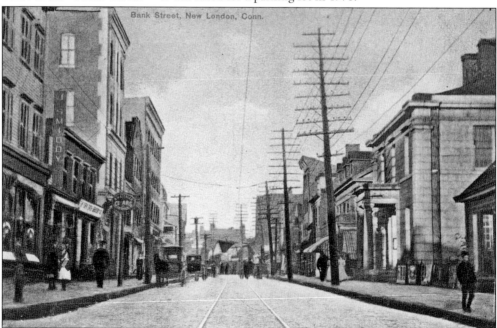

This postcard of Bank Street looks north from Pearl Street. The Greek Revival building at right is the US Custom House; it is the oldest continuously operating custom house in the nation.

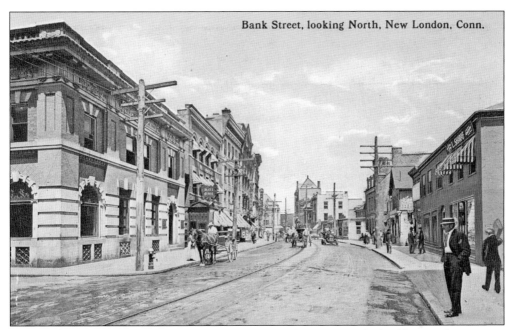

This postcard shows Bank Street looking north from Golden Street. The building on the corner at left is the New London City National Bank, which was erected around 1905. This bank merged with the Hartford National Bank & Trust Company in 1953, and this office was later moved to the New London Shopping Center. This site is now occupied by Liberty Bank.

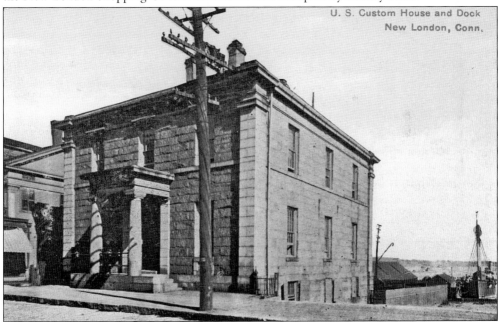

Architect Robert Mills designed and built the US Custom House in 1833 in the Greek Revival style. (Mills also designed the Washington Monument in Washington, DC.) Located at 150 Bank Street, it is the oldest continuously operating custom house in the nation. Its front doors are made of wood from the USS *Constitution*. A light ship is at its mooring in the lower right corner of this image. The New London Maritime Society now operates a museum at this site.

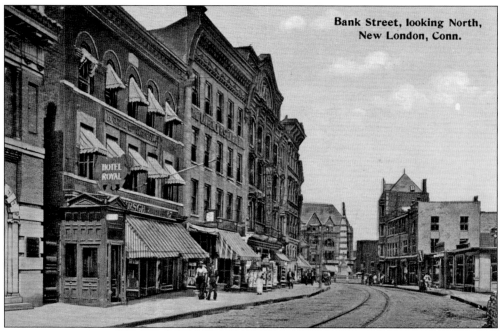

Bank Street, looking North, New London, Conn.

This c. 1913 postcard of Bank Street looks north toward the Soldiers and Sailors Monument. At left (with window awnings and a canopy) is the Hotel Royal at 57 Bank Street. The hotel was previously known as the Bacon House (also a hotel). It burned down in 1897 and was rebuilt.

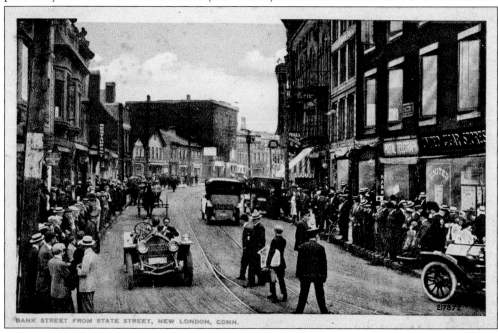

This postcard, looking southwest from lower State Street, shows two-way traffic on Bank Street. Many of the buildings on both sides of the street are still standing today. The building at left with two chimneys was the National Whaling Bank; today, it is Muddy Waters Cafe. Note the police officer standing inside the trolley tracks to direct automobile and horse-drawn carriage traffic. Motor vehicles arrived in New London around 1900.

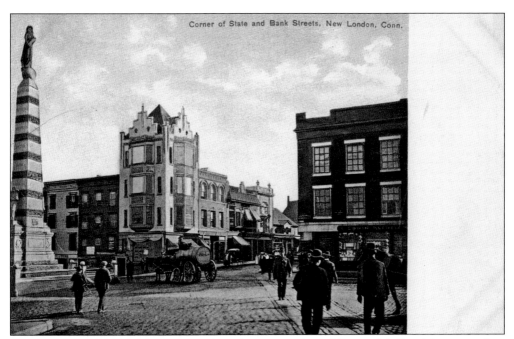

This postcard offers a view of State and Bank Streets. The Soldiers and Sailors Monument is at left. The structure beyond the horse-drawn cart, known as the "cube building," was erected in the early 1920s and has only one room on each floor; the first floor is now home to a fast-food franchise. The building at right was once Whelan Drug Store.

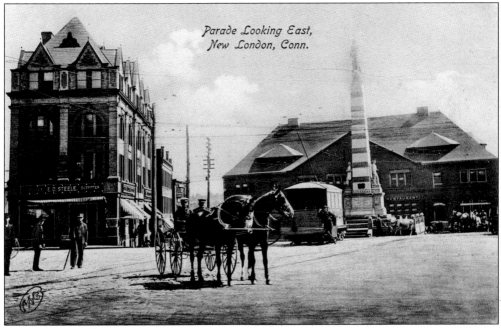

The Parade area is shown in this east-facing view. Beyond the Soldiers and Sailors Monument is Union Station, which was designed by architect Henry Hobson Richardson. At left is the Neptune Building, which was torn down during redevelopment in the 1960s; Union Station was spared from demolition. Note the cow hitched to the monument's base rail.

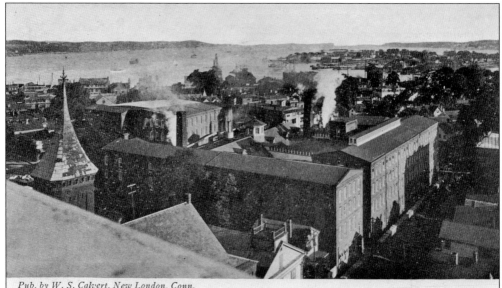

Pub. by W. S. Calvert, New London, Conn.

334— Bird's*Eye View of New London

This postcard shows the Palmer Brothers Quilt Mill, which was located on Washington Street. The steeple of State Street Baptist Church, now known as the Church of the City, New London, is also visible.

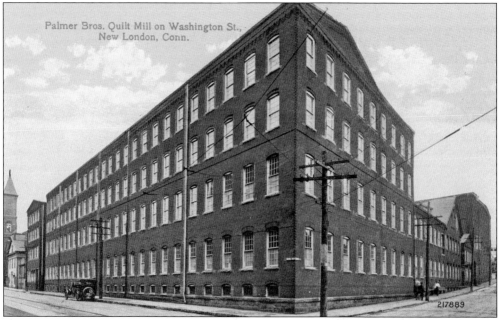

Palmer Bros. Quilt Mill on Washington St., New London, Conn.

217889

The Palmer Brothers Quilt Mill was one of several factories in New London, Fitchville, and Montville, Connecticut. This factory, which made quilts for steamship liners, closed in 1918. This structure was razed; the First National Store was built here in the 1950s, and the site was rebuilt upon by the Southern New England Telephone (SNET) Company in the 1960s. Washington Street is at left, and Methodist Street is to the right. The steeple of State Street Baptist Church is visible in the distant left background.

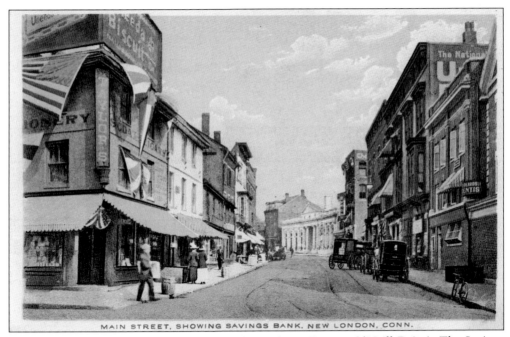

This c. 1930 view looks north down Main Street (now Eugene O'Neill Drive). The Savings Bank of New London is in the distance. In the 1940s, Schulte, a cigar and tobacco store, was at near right, and Ye London Grill was at near left.

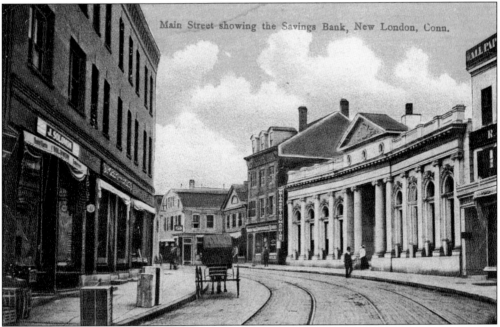

Main Street showing the Savings Bank, New London, Conn.

The Savings Bank of New London, shown at right with a couple near the doorway, was chartered in 1827. In 1852, it opened this building at 63 Main Street. At the time of its closure, in 1993, it was known as the New England Savings Bank. Today, it is the Citizens Bank. The exterior was made of pink granite quarried in Milford, Massachusetts. The carriage at left is parked outside of 30 Main Street; the sign over the door reads "J. Solomon," the name of a stationery store.

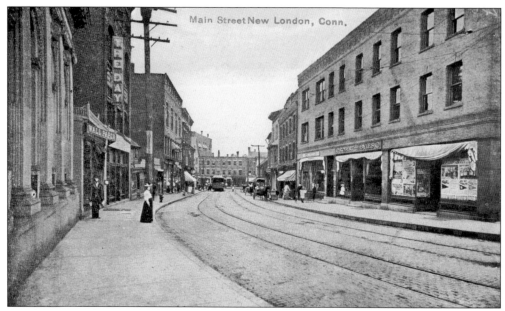

This postcard shows Main Street looking west toward State Street from Savings Bank of New London. One of the storefronts at right is Robert H. Byles, undertaker, at 52 Main Street. At left, beyond the man and woman on the sidewalk, are R.J. Sisk's wallpaper store, at 51 Main Street, and the offices of the *New London Day* newspaper.

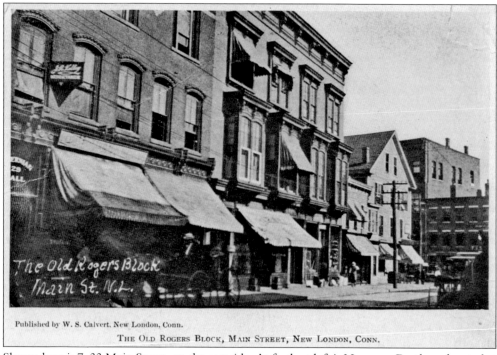

Published by W. S. Calvert, New London, Conn.

THE OLD ROGERS BLOCK, MAIN STREET, NEW LONDON, CONN.

Shown here is 7–33 Main Street, on the east side. At farthest left is Newman Brothers, located at 33 Main Street. The second-story sign at 29 Main Street reads "J.N. Kelley, Undertaker." The Hibernian Hall was upstairs. The third canopy from the left marks E. Callahan Jr., druggist, at 27 Main Street. (Courtesy of David Morrison.)

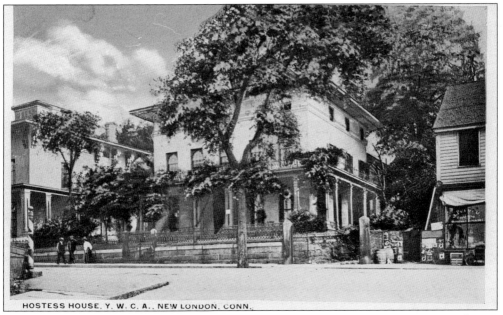

HOSTESS HOUSE, Y. W. C. A., NEW LONDON, CONN.

This c. 1913 postcard shows "the Lawrence house," believed to be at 250 Main Street, at the top of Hallam Street (which is no longer in existence). This house and the house at left were built in the Italianate style by Joseph Lawrence, a famous shipping and whaling agent, who could walk from here down Hallam Street to the wharves. His sons later occupied the homes. The building was used as a YWCA Hostess House during World War I and was removed during redevelopment in the 1960s and 1970s.

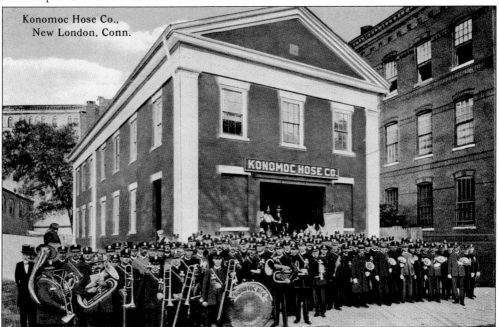

The Konomoc Hose Company building, located at 4 Union Street, was demolished during redevelopment in the 1960s and 1970s. Konomoc was once the largest volunteer fire company in Connecticut. This building formerly housed the Union Street School.

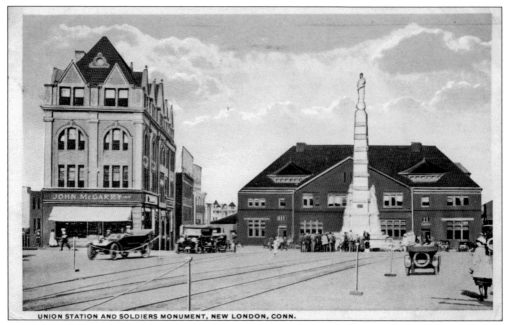

The John McGarry business was located in the Neptune Building (left) at 27 State Street. To the left of the building is Atlantic Street at the corner of Bradley Street (now North Bank Street). Behind the building, to the east, was Potter Street. All the structures at left were demolished in the 1960s; all that remained from the scene pictured here were the Soldiers and Sailors Monument and Union Station.

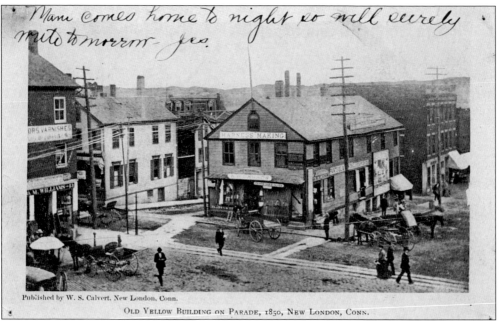

This postcard looks east from State Street toward Bradley Street (now North Bank Street). Referred to as "the old yellow building," it served as a combined harness-making and hardware store. The Neptune Building, originally slated as a seafood retail store, replaced it in 1906. The Salvation Army purchased the Neptune Building during the 1920s.

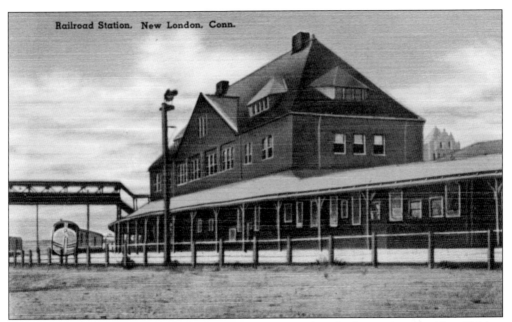

On this postcard, a diesel train enters beneath the pedestrian bridge at the east side of Union Station. The footbridge, installed in 1912 for the public welfare based on a decision by the Public Utilities Commission, was removed in 1961.

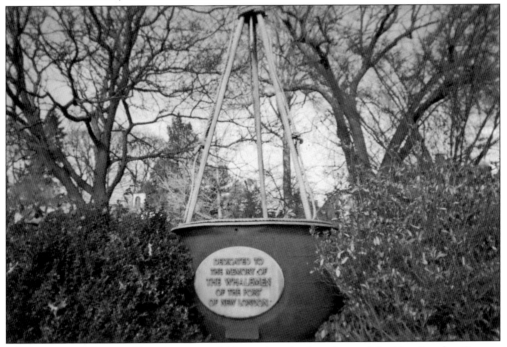

This antique whaling cauldron is a memorial located on the front lawn of the New London County Historical Society at 11 Blinman Street. The inscription states: "Dedicated to the memory of the whalemen of the port of New London." The cauldron (with harpoons), previously located east of the base of the Soldiers and Sailors Monument, was brought to the grounds of the Shaw Mansion around 1941. (Photograph by Ann Marie Keating.)

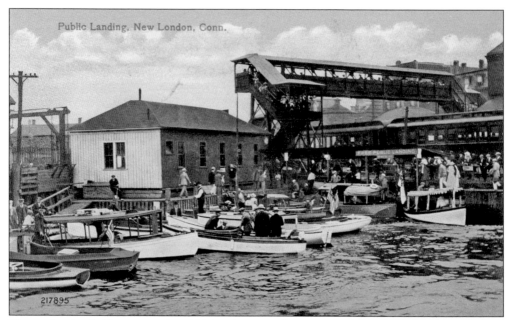

The pedestrian bridge, erected in 1912 and removed in 1961, is shown over a stopped train at Union Station around 1915. The Chappell Coal Yard sheds (not shown) were at far left.

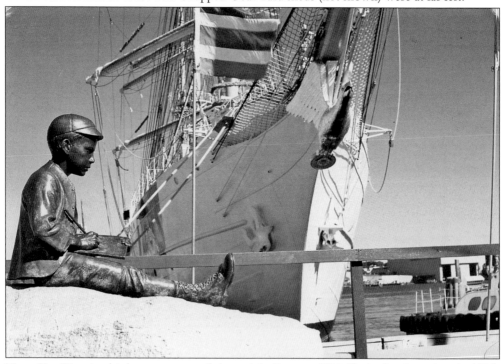

Near City Pier sits this bronze statue of playwright Eugene O'Neill, depicted as a boy in 1895, sitting on a rock wearing an Eton-style hat. The statue is next to the US Coast Guard barque *Eagle*. O'Neill, winner of the Nobel Prize and four Pulitzer Prizes, spent his childhood at Monte Cristo Cottage on Pequot Avenue. The statue was created by Norman Legassie and commissioned by George White. (Photograph for this postcard by Bernard L. Gordon.)

Two

WATERWAYS

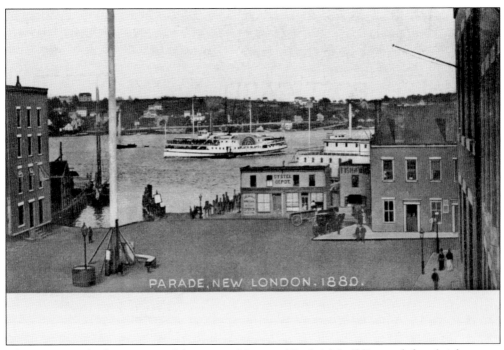

This 1880 view looks east toward the town of Groton. The brick buildings at left and right are on the sites of former train stations that were destroyed by fire and replaced by Union Station around 1887. At left is the liberty pole before it was replaced by the Soldiers and Sailors Monument. The side-wheeler *Block Island* is in the water at center.

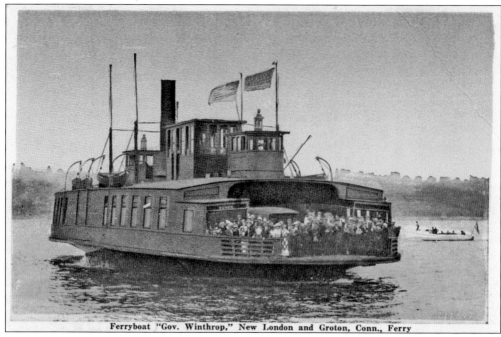

Ferryboat "Gov. Winthrop," New London and Groton, Conn., Ferry

The ferryboat *Gov. Winthrop* carried workers, as well as regular travelers, between New London and General Dynamics (in Groton). The boat was built sometime between 1904 and 1906. The ferry crossing to Groton ended in 1929.

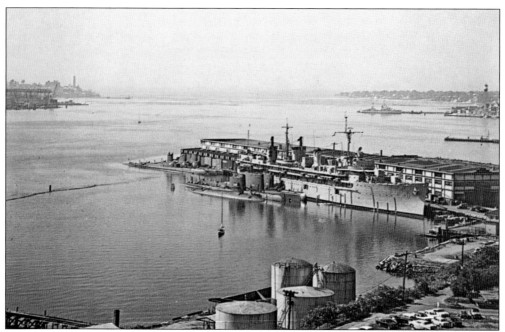

USS *Fulton* launched in December 1940. In 1991, she was decommissioned; at that time, she was the third-oldest ship in the Navy. In 1988, she was the flagship of Submarine Squadron 10. The *Fulton* is shown here flanked by submarines at the State Pier in East New London (this area is known as "the neck"). (Photograph for this postcard by Ike Beck.)

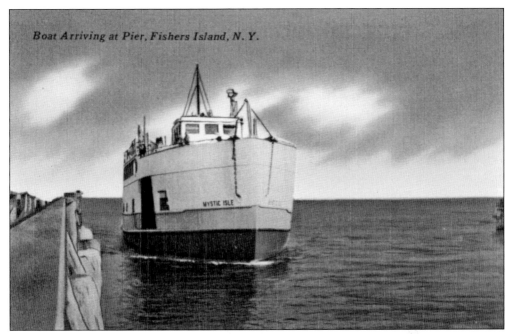

Boat Arriving at Pier, Fishers Island, N.Y.

The ferryboat *Mystic Isle* ran between New London and Fishers Island, New York. It held about 14 vehicles and was approximately 100 feet in length and 30 feet wide. It was brought to New London from Sandusky, Ohio, and remained in operation from 1951 until late 1977.

A ferry similar to this one was used for transportation between Orient Point, New York, and New London—an approximately 17-mile trip. In the 1950s, the wharf was located to the rear of the Tradewinds Restaurant at 130 Pequot Avenue, and many trucks coming from Long Island loaded with potatoes landed here. Today, a dockominium and a restaurant are at this location.

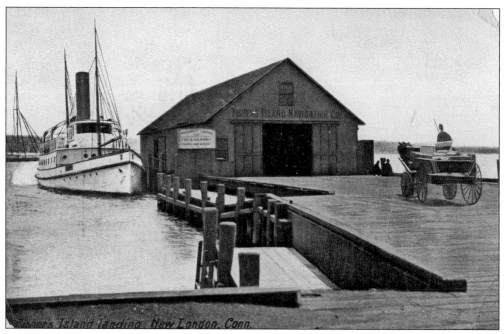

A boat belonging to the Fishers Island Navigation Company is docked at the Fishers Island Landing at the New London waterfront on a slow day.

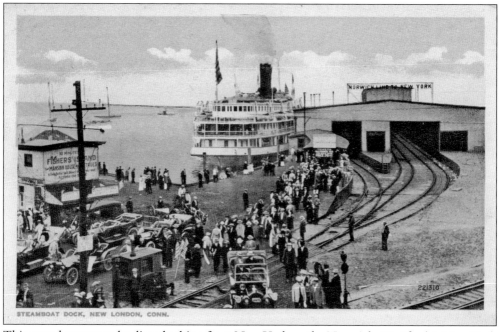

This crowd appears to be disembarking from New York on the Norwich, Hartford & New York line. Note the then-modern convertibles on this c. 1920 postcard.

44

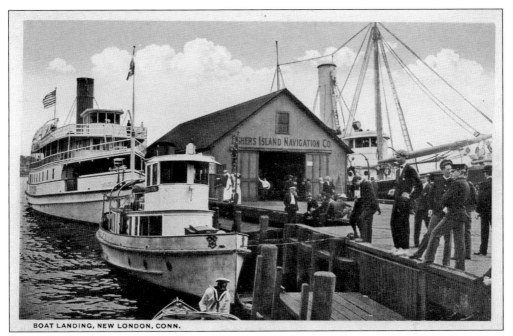

BOAT LANDING, NEW LONDON, CONN.

This postcard depicts a busy day on the Fishers Island piers in downtown New London. Note the uniformed sailors. The ferry *Restless* appears to be in the back at left.

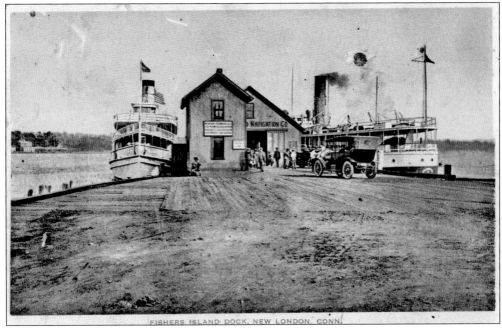

FISHERS ISLAND DOCK, NEW LONDON, CONN.

This is a long view of the Fishers Island wharf. Note the vehicles on the pier. The boats resemble the *Restless* (1900–1926) at left and the *Munnatawket* (1890–1938) at right. Today, a car-and-passenger ferry named the *Munnatawket* runs between New London and Fishers Island.

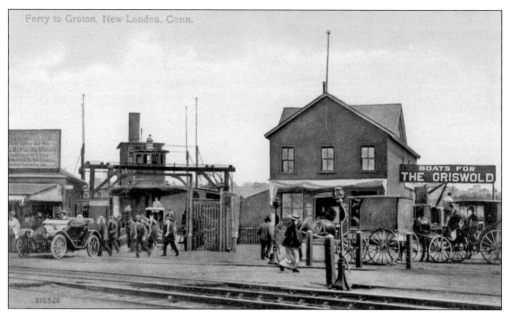

The ferry *Gov. Winthrop* (left) provided commuter transportation across the Thames River between Groton and New London. The slip at right is for the shuttle to the Griswold Hotel in Groton. The *Gov. Winthrop*, as well as the ferry *Griswold*, stopped operating when the road bridge was completed in 1929. The young man who wrote on the reverse side of this card pointed out to his grandmother that the building between the two boats is a "wholesale fish house."

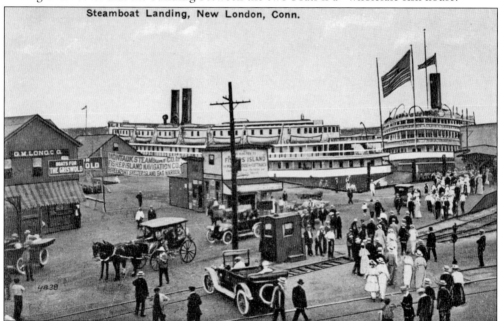

This c. 1916 postcard shows a cluster of people, cars, and horses amid the steamboat landing for the Griswold Hotel, Fishers Island, Sag Harbor, Greenport, and Shelter Island. The G.M. Long Seafood Company (established in 1868), Griswold Hotel, Groton Transportation Boat, Fisher's Island ferry slip, and the New York, New Haven & Hartford were all at the foot of State Street. G.M. Long later relocated to the Groton side of the Thames River.

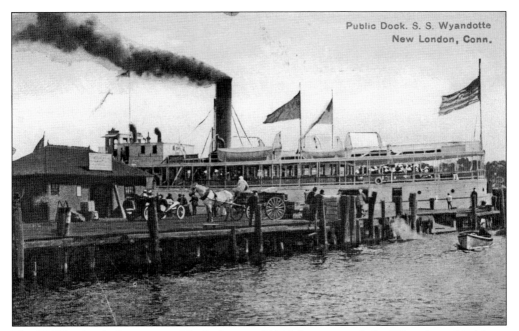

The SS *Wyandotte* is shown at a public dock around 1912. It was named after Wyandotte, Michigan, where the steamer was built. The city of Wyandotte, incorporated in 1867, was named after a local Native American tribe. According to Dirk Langeveld, a writer for patch.com, shipbuilding was active there from 1870 to 1920. This boat was replaced by the steamer *Shinnecock* in 1923.

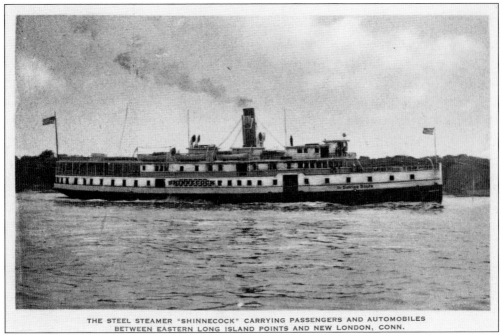

The steamer *Shinnecock* was named after a Native American tribe on Long Island, New York. It traveled to New London, Block Island, Rhode Island, and Long Island around the start of the 20th century.

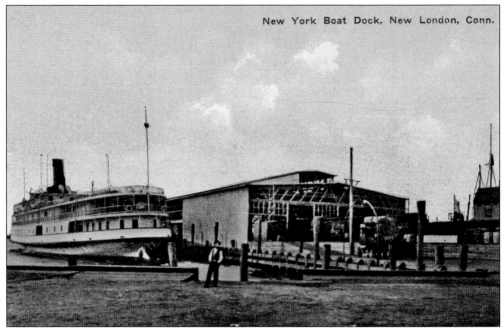

This c. 1910 postcard shows a quiet interlude in a normally active location at the New York Boat Company dock.

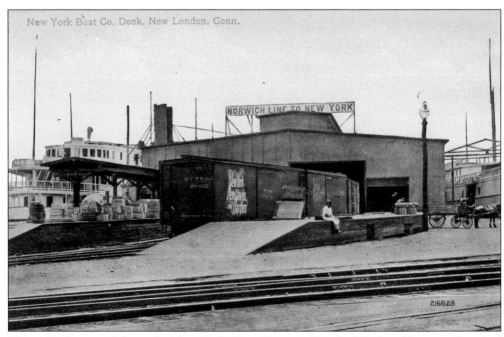

This c. 1910 postcard shows the New York, New Haven & Hartford Rail and Steamer Terminal at the New York Boat Company dock. The steamer at left is unidentified.

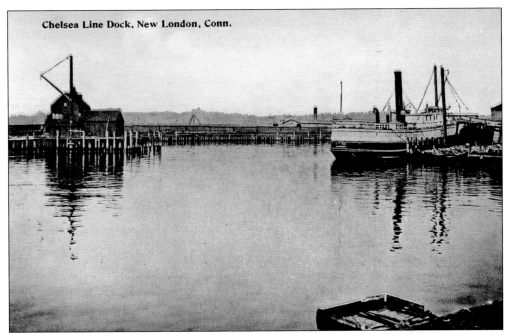

Chelsea Line Dock, New London, Conn.

This postcard, dated to between 1907 and 1916, shows the Chelsea Line dock at right; the dock was used for passenger-ship transportation to New York on the east side of the Hudson River. The Chelsea Line Warehouse was located north of Water Street, near the Hallam Street crossing east of the entrance to Winthrop Cove. The Chelsea Line dock was destroyed by fire in 1916.

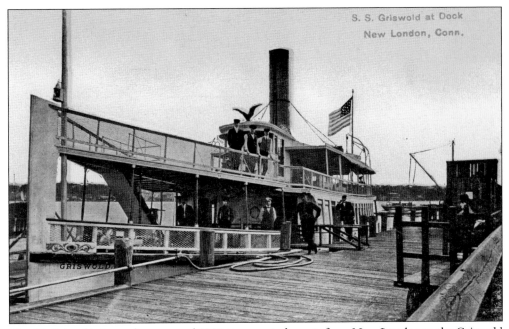

S. S. Griswold at Dock
New London, Conn.

The SS *Griswold*, shown here around 1907, transported guests from New London to the Griswold Hotel in Groton, which opened around 1906.

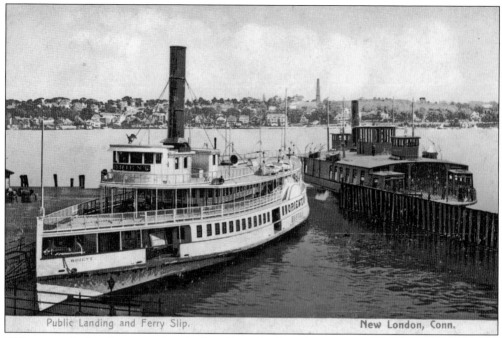

Public Landing and Ferry Slip. New London, Conn.

This postcard, dated to sometime before 1907, displays the ferryboat *Orient* (left) and, to the south, the ferryboat *Gov. Winthrop* (right). The oblique tower at Fort Griswold in Groton, Connecticut, is visible in the background.

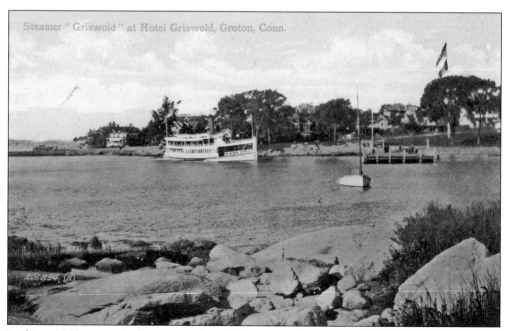

Steamer " Griswold " at Hotel Griswold, Groton, Conn.

In this c. 1908 postcard, the steamer *Griswold* arrives at the Griswold Hotel Pier in Groton with her passengers.

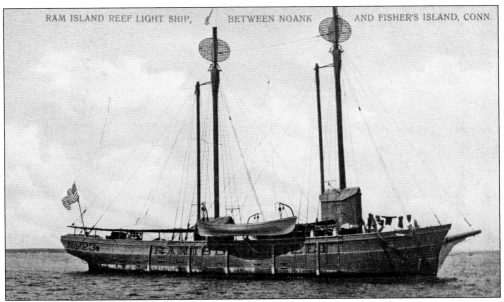

The lightship No. 23, *Ram Island*, is shown sometime after 1907. This boat occasionally moored at the US Coast Guard buoy station behind the US Custom House on Bank Street. Note the multiple masts. The boat was normally anchored in deep water, where a foundation for a permanent lighthouse could not be established. Boat crews maintained the light, tracked the weather, and noted nearby watercraft. Some of these vessels were lost to hurricanes and ramming.

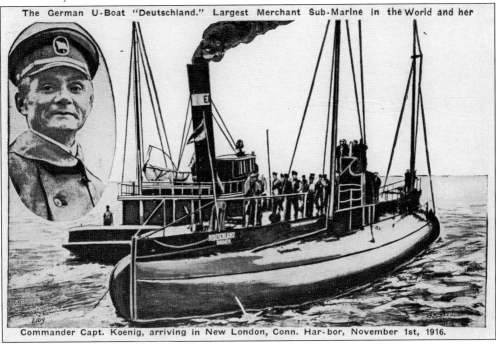

The German U-Boat "Deutschland." Largest Merchant Sub-Marine in the World and her

Commander Capt. Koenig, arriving in New London, Conn. Har-bor, November 1st, 1916.

In 1916, the German submarine *Deutschland* arrived in New London with its commander, Captain Koenig (shown). According to Gregory N. Stone, author of *The Day Paper*, the submarine rammed the tug *T.A. Scott Jr.* while being escorted out to sea, and the tug crewmen drowned. Aid and rescue support was provided by the crew of another escort tug, *Cassie*.

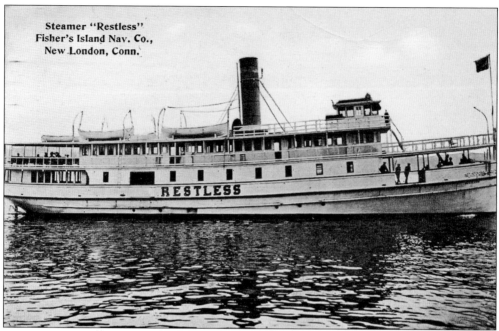

The Fishers Island Navigation Company operated the steamer *Restless* from 1900 to 1924. It was named after Dutch admiral Adrian Block's boat *Onrust*, interpreted as "restless." The writer of this postcard noted that he saw Fort H.G. Wright at Fishers Island, New York.

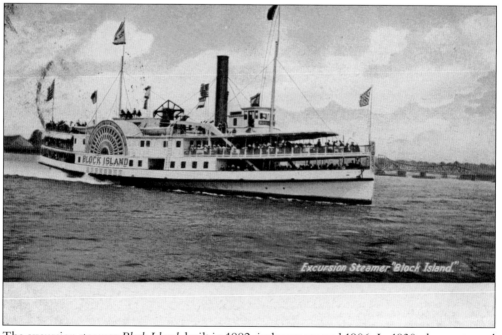

The excursion steamer *Block Island*, built in 1882, is shown around 1906. In 1930, she was towed to Dyer Island, Rhode Island, and burned. Dyer Island is in Narragansett Bay.

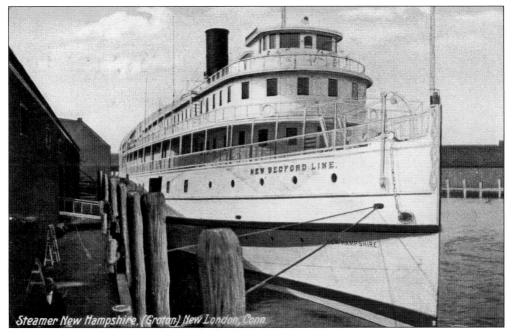

The steamer *New Hampshire* is shown here in 1907. Built around 1892, it was probably owned by the New York, New Haven & Hartford Railroad.

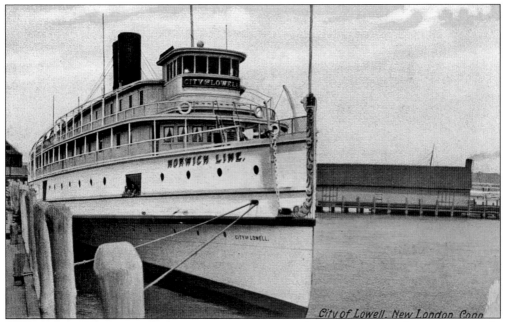

Tied to the dock is the steamer *City of Lowell*, a Norwich Line steamer built in 1894 in Bath, Maine, that was 322 feet long by 50 feet wide. It ceased operating in 1939.

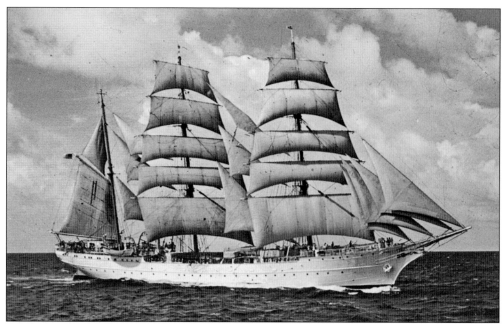

The US Coast Guard barque *Eagle*, a square rig, was taken as a trophy from Germany in World War II and is used as a training ship for US Coast Guard Academy cadets. It was originally named *Horst Wessel*. This photograph precedes the colored stripes (red, white, and blue) approved by Pres. John F. Kennedy and USCGA commandant Adm. Edwin Roland in the 1960s and added in the 1970s. This boat's home station is New London at the pier alongside Fort Trumbull.

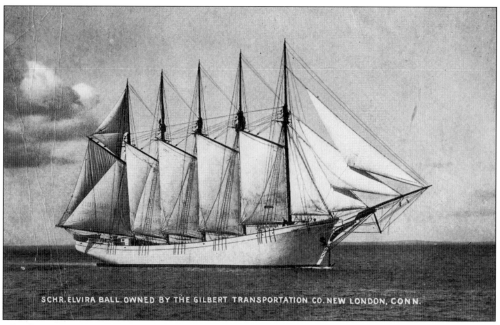

SCHR. ELVIRA BALL. OWNED BY THE GILBERT TRANSPORTATION CO. NEW LONDON, CONN.

The five-masted schooner *Elvira Ball* was built by the Gilbert Transportation Company in 1906 in Mystic, Connecticut. She was lost at sea in 1909.

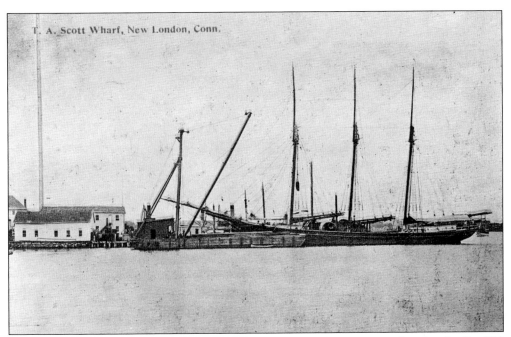

The three-masted schooner *Blossom* is berthed alongside a barge at T.A. Scott's wharf at 300 Pequot Avenue. The *Blossom* was about 100 feet in length and 20 feet in width. It was renamed for Elizabeth Bingham Blossom. This view is to the north.

Boats are clustered at T.A. Scott's wharf at 300 Pequot Avenue in this south-facing postcard. The schooner *Blossom*, the three-masted boat right of center, sailed to the South Seas in 1923 on a scientific voyage.

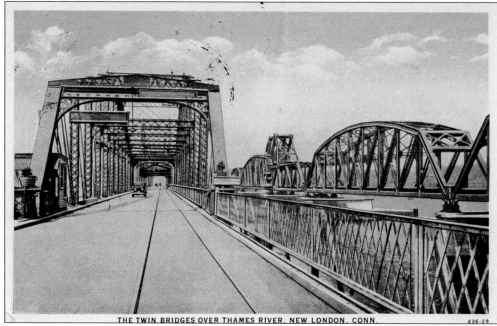

The railroad bridge at right, built in 1918–1919, replaced the first bridge, which was built in 1889. The car at left is on the old railroad bridge, which opened to vehicles and pedestrians in 1929 for travel between New London and Groton. Both are moveable bridges. This postcard appears be from the late 1930s. Of the eight movable bridges in Connecticut, two are located in New London—one replaced the train bridge shown here, and the other is located in Shaw's Cove. The Gold Star Memorial Bridge (not shown) opened in early 1943; It is 6,293 feet long and stands approximately 135 feet above the Thames River.

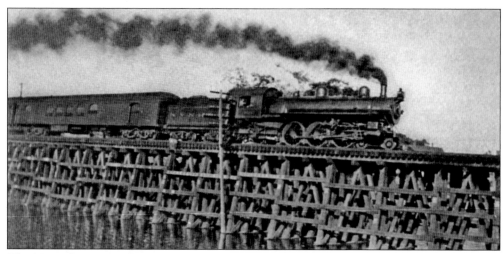

The Limited Express, shown on the Winthrop Cove Trestle around 1927, was a three-wheel (drive-wheel) steam engine.

Three

OCEAN BEACH

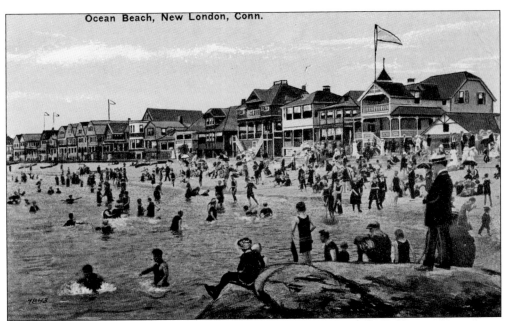

Ocean Beach is shown here prior to the 1938 hurricane. This photograph would have been taken from the pier. Before the hurricane, summer houses lined the beach.

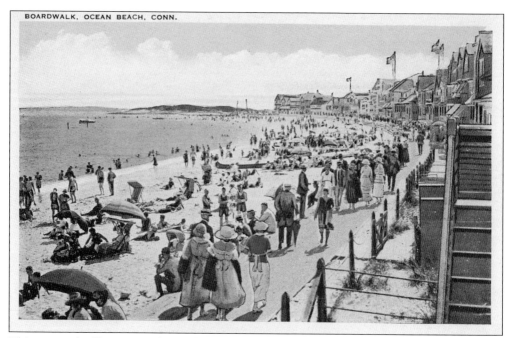

This postcard offers a view from the boardwalk looking south toward Waterford prior to the 1938 hurricane.

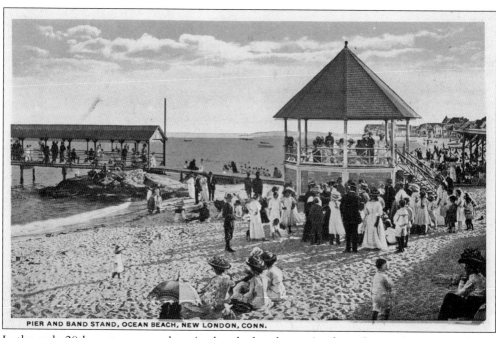

PIER AND BAND STAND, OCEAN BEACH, NEW LONDON, CONN.

In the early 20th century, crowds arrived at the beach wearing long dresses, bonnets, and suits for socializing at the pier and the bandstand.

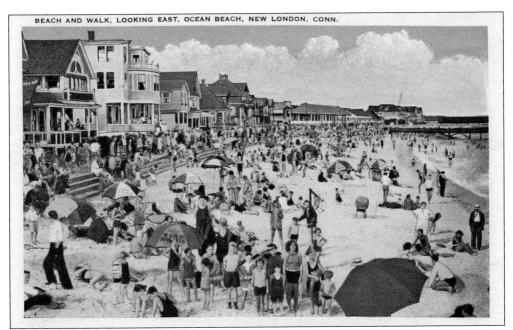

In the foreground of this postcard, which looks east, children pose in bathing suits at the beach. Behind them, a life preserver hangs from a pole, and nearby is a baby carriage. Crowds travel along the walk to the left.

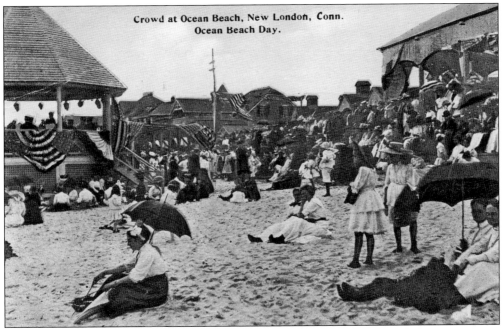

Crowd at Ocean Beach, New London, Conn.
Ocean Beach Day.

Crowds arrived in throngs for the annual Ocean Beach Day, pictured here sometime prior to the 1938 hurricane. A band is in the gazebo. Note the American flags and banners, which can been seen in so many vintage photographs from the early 20th century. The Ocean Beach Day celebration continued each year until at least the 1950s.

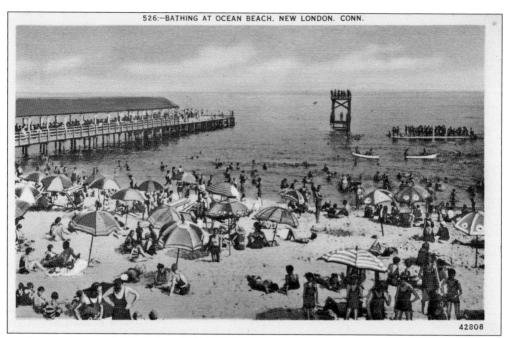

42808

Umbrellas dot the sand in this scene from Ocean Beach. Swimmers and boaters are in the water. The more daring people enjoy rafts and a diving platform. This postcard dates from between the mid-1930s and the early 1940s.

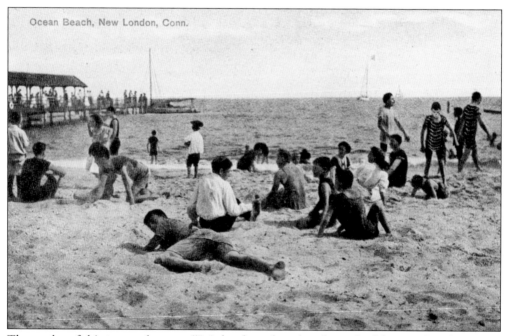

Ocean Beach, New London, Conn.

The sender of this postcard wrote, "It is lovely and cool at the end of that pier." Others seem to be enjoying the sand on the beach. Note the striped bathing suits of the young men at right; this was a popular style in the early 20th century.

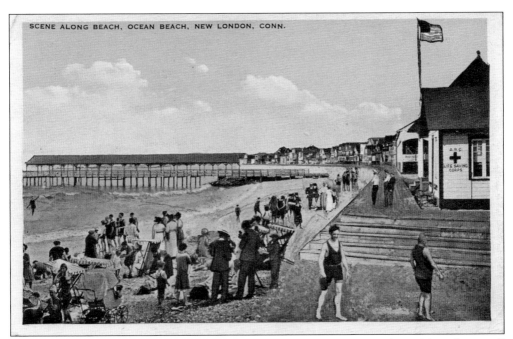

The American Red Cross Life Saving Corps building is shown at right. With such a small crowd, mostly dressed in formal outfits, there may not have been much business for the medical workers on this particular day.

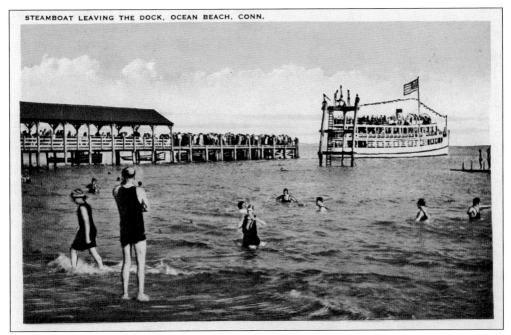

A big crowd sees off the sightseeing excursion boat leaving the pier. A few swimmers have taken to the water, the raft (far right), and the diving platform.

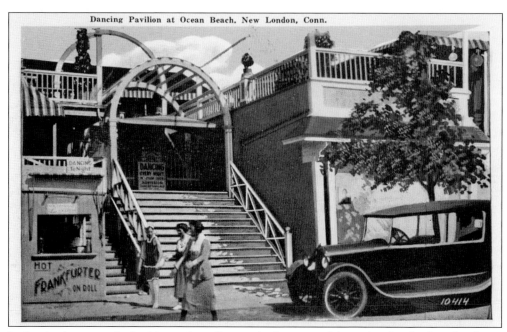

Dancing Pavilion at Ocean Beach, New London, Conn.

Ladies in dresses and a bathing suit walk past the bottom of the stairs that lead to the dance pavilion. The sign at the top of the stairs advertised "dancing every night."

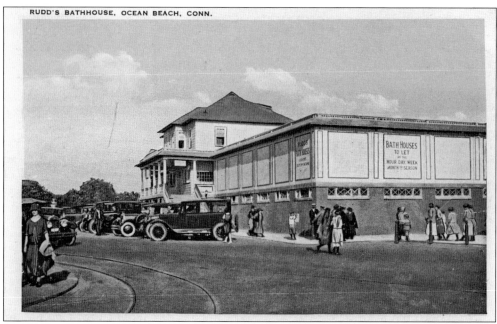

RUDD'S BATHHOUSE, OCEAN BEACH, CONN.

Cars line up outside A.G. Rudd's bathhouse and dance hall. The popular dance hall was known as "Danceland, the Garden of Roses." Rudd was a dance teacher and roller-skating instructor.

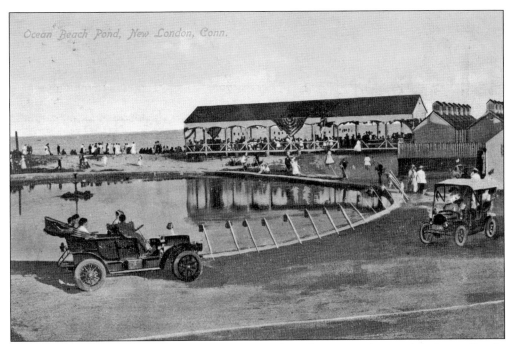

This 1909 postcard shows guests sitting in cars and strolling around a pond at Ocean Beach. Others are enjoying the seating area under a pavilion. The bathhouses are at right.

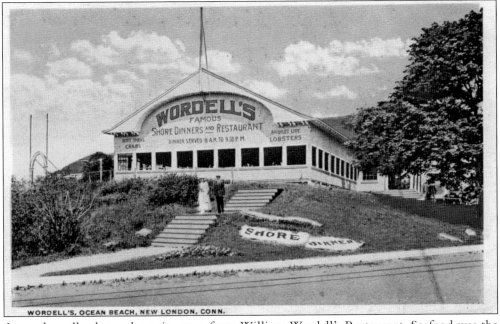

A couple walks down the stairs away from William Wordell's Restaurant. Seafood was the advertised fare, and meals were served from 8:00 a.m. to 9:30 p.m. Wordell's later became Club Valhalla, which caught on fire in early 1932.

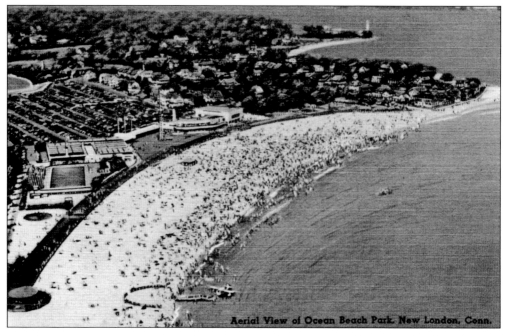

The rotunda is in the lower left corner of this c. 1946 postcard. On its right is the "Flying Service." Above the rotunda are the children's playground and circular wading pool, swimming pool, and bathing lockers. Beyond this are the carousel, dodgem, miniature railroad, parking lot, the Theme Tower, the Gam, a recreation hall, miniature-golf course, and the residential area of Neptune Park.

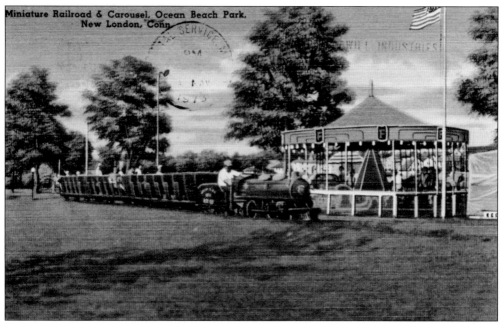

The miniature railroad and carousel, shown here around 1950, became a favorite of many patrons over the generations. The miniature railroad circled around a large figure-eight path, offering views of the beach.

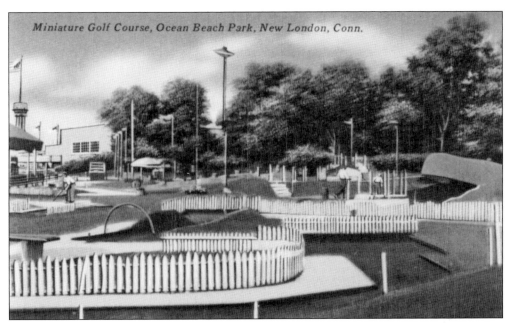

Miniature Golf Course, Ocean Beach Park, New London, Conn.

The miniature-golf course, built after the 1938 hurricane, had 18 holes, many created in the likenesses of landmarks of New London, including the Old Town Mill. The mouth of the whale (at far right) always proved to be a challenge when trying to tap in the ball.

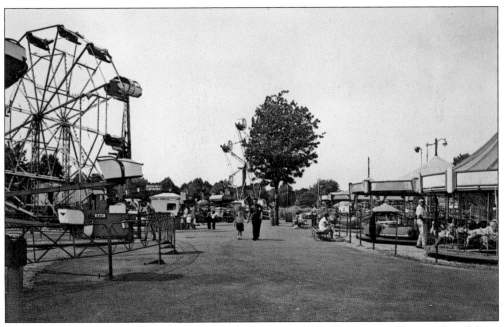

The Ocean Beach amusement park is shown here around 1960. Tickets could be purchased from the white booth (left of center) for one of the many rides, including the carousel (right), bumper cars (not shown), and various Ferris wheels (center and left). The center of this postcard features a policeman walking with a child.

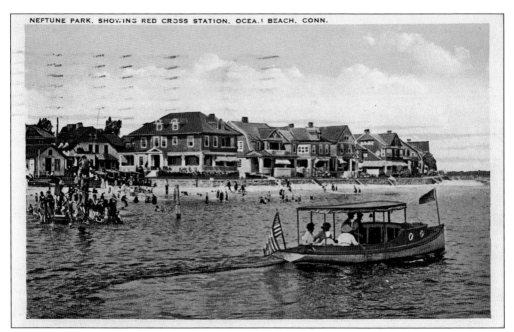

In this image, taken before the 1938 hurricane struck the coast, some folks are out for a cruise on a boat, and the raft is packed with swimmers. The houses are part of Neptune Park. Cars are parked at the edge of the beach just to the left of the houses. Today, this area is fenced off, and parking is for residents only.

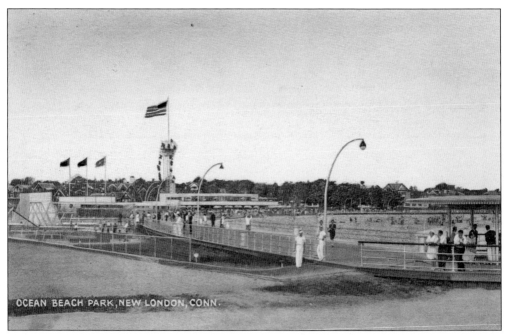

OCEAN BEACH PARK, NEW LONDON, CONN.

Sailors in white, along with other visitors, stroll along the boardwalk. The American flag flies atop the Clock Tower, which was an Ocean Beach landmark and a favorite meeting spot before the days of cell phones. The tower was torn down in the late 1980s. The flat-roofed building behind and to the right of the Clock Tower is the Gam.

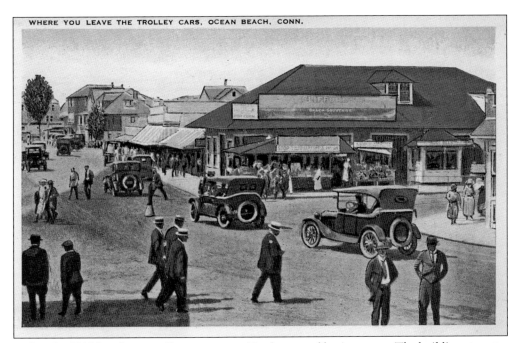

Before the 1938 hurricane, trolley cars stopped in the central business area. The building at center was Clifford's, which advertised popcorn and beach souvenirs on roof signs.

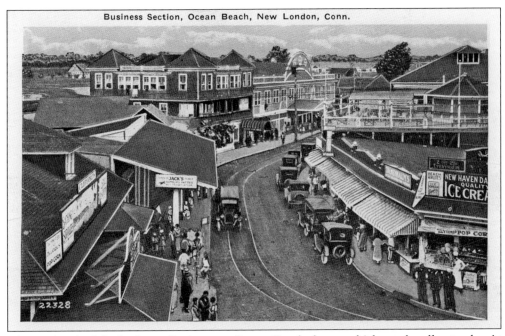

Business Section, Ocean Beach, New London, Conn.

This postcard of the business district near Ocean Beach shows vehicles and trolley tracks. At left are Clifford's and Jack's Restaurant, which is advertising hamburger patties. At right, three sailors stand in front of a store advertising ice cream and buttered popcorn.

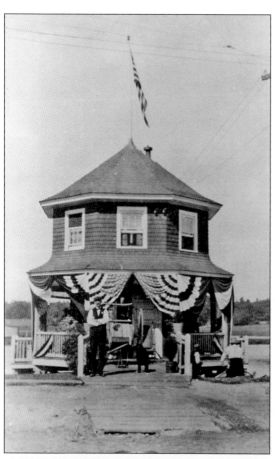

This octagonal building at Ocean Beach housed the fire department and police department prior to the 1938 hurricane. (Courtesy of David Morrison.)

This more modern 1960s photograph shows the picnic area located between the beach and the rides. Friends and families would gather under the shade of these trees to eat and socialize. (Photograph for postcard by Ike Beck.)

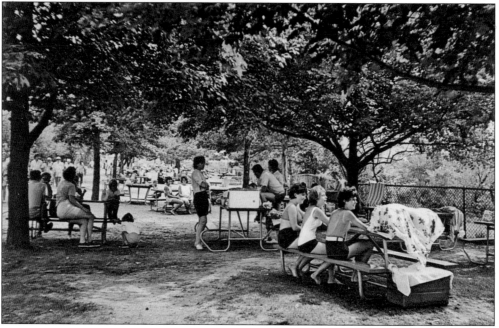

Four

STREETS AND
PLACES OF INTEREST

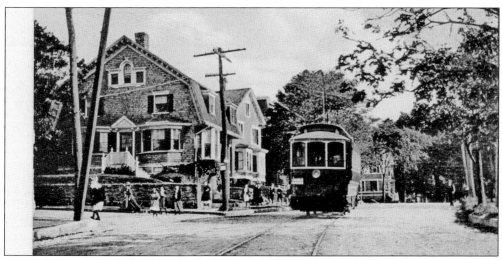

This postcard shows the trolley dropping off students of the Nathan Hale Grammar School at the corner of Williams and Waller Streets. Trolleys ran through New London from about 1892 until 1932. (Courtesy of David Morrison.)

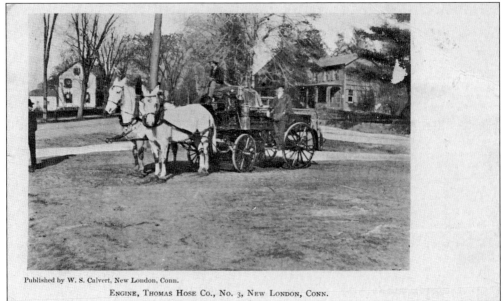

Published by W. S. Calvert, New London, Conn.

ENGINE, THOMAS HOSE CO., No. 3, NEW LONDON, CONN.

A horse-drawn carriage and firefighters of the Hodges Square W.B. Thomas Hose Company No. 3 are pictured at 389 Williams Street. In 1936, the old structure was demolished, and a new building was erected. The new one was, in turn, demolished for the construction of the second span of the Gold Star Memorial Bridge. (Courtesy of David Morrison.)

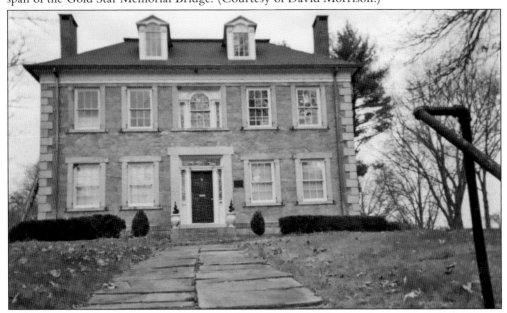

The Federal-style Deshon-Allyn House, at 625 Williams Street, was constructed for Daniel Deshon, a New London whaling captain. In 1851, whaling and shipping agent Lyman Allyn purchased it. His daughter Harriet Allyn Upton left money for the construction of the Lyman Allyn Art Museum (built in 1932) in memory of her father. The house is part of the museum property and was listed in the National Register of Historic Places in 1970. The property also contains the September 11th McCourt Memorial Garden, which honors the people of southeastern Connecticut who lost their lives on September 11, 2001. (Photograph by Ann Marie Keating.)

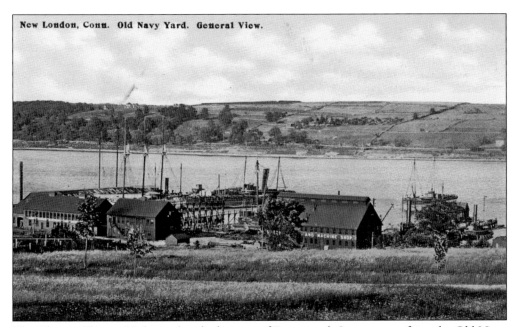

New London, Conn. Old Navy Yard. General View.

The Thames Shipyard is located at the bottom of Farnsworth Street across from the Old Navy Yard in Groton. Founded in 1900, it was once owned by the Chappell family and has been operated by the Wronowski family since 1967. According to historian Alex Gratiot, writing for the National Park Service, as of 1978, "the yard contains the oldest known steam powered marine railway in the U.S."

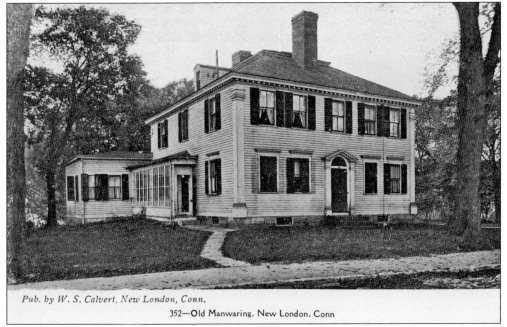

Pub. by W. S. Calvert, New London, Conn.
352—Old Manwaring, New London, Conn

Manwaring House was located near the top of Manwaring Hill, southeast of the parklet on Williams Street. Locals used to refer to it as the "Dolly Madison House," because it was known that she visited here on occasion. The house was dismantled and shipped to another state. The Madry Temple Church now sits where this structure was located.

71

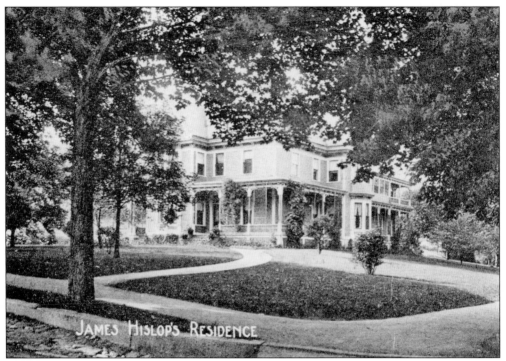

The James Hislop residence stood at the corner of Vauxhall and Williams Streets. The family operated the S. Hislop Company in the Harris Building at 153–157 State Street. In the 1930s, this house was replaced by the Smith Memorial Home. (Courtesy of Bygone Era Photos.)

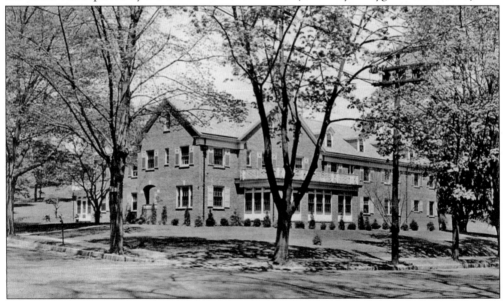

In the early 1930s, this brick building at the corner of Vauxhall and Williams Streets replaced the James Hislop residence and was named after Dr. Seth Smith, a New London physician and pharmacist who left an endowment—the Smith Memorial Fund—in his will to care for aging women (see page 19). The home had 20 bedrooms. The Smith Memorial Fund sold the building in 1990, and it is now occupied by a day-care center. (Courtesy of David Morrison.)

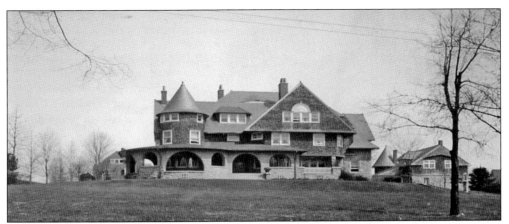

In 1896, G.W. Dietrich of New York designed this private home at 31 Vauxhall Street, part of Post Hill Place, for Frederick S. Newcomb. Newcomb was a New London dry-goods merchant. The pink granite on the first level came from a Maine quarry and was brought by barge. In the early 1950s, this building was converted into a convalescent home called Beechwood Manor. Post Hill Place was shortened to about 1,000 feet in order to expand Interstate 95 and the Gold Star Memorial Bridge. Beechwood Manor is part of the Post Hill Historic District, which was listed in the National Register of Historic Places in 1993. (Courtesy of Walter Watson and Charles Sotir.)

This is the corner of Broad and Williams Streets, looking east. The large brick building at left is 183 Williams Street, built around 1890 by the Bragaw family. Elias T. Bragaw (1836–1927) was the third-oldest member of the New York Stock Exchange. There was a traffic rotary at this intersection in the 1940s and 1950s. The building behind the Bragaw mansion, known as Ye Faire Harbour Apartment House, stood at 121–123 Broad Street; with its approximately eight units, it was the first apartment house built in New London.

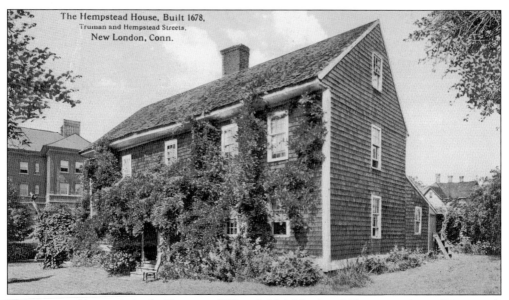

The Hempstead House, Built 1678,
Truman and Hempstead Streets,
New London, Conn.

The Hempsted house sits in the Hempstead Historic Neighborhood. Ten generations of Hempsteds lived on this property. Joshua (son of Robert, one of the first English settlers of New London) built the western half of the house in 1678. Joshua's grandson Nathaniel doubled the size, turning the home into a center-chimney Colonial in 1728. His son Joshua kept a diary from 1711 to 1758, providing a detailed record of life in New London. The Saltonstall Grammar School (see page 114), built in 1903, is in the background at left.

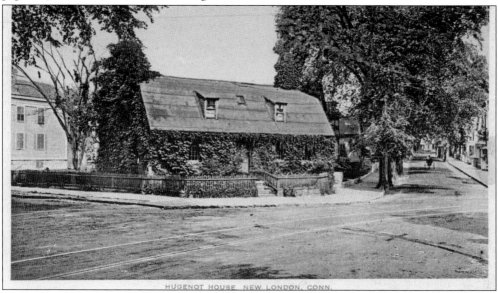

HUGENOT HOUSE, NEW LONDON, CONN.

This house, built in a center-hall gambrel style, was constructed by the great-great-grandson of Robert Hempsted, one of the first English settlers of New London, and grandson of the diarist Joshua Hempsted. Joshua owned a slave named Adam. Future generations of Hempsteds became active members of the abolitionist movement of New London. Also known as the Huguenot House, this may have been built by Huguenot refugees from France or French-speaking Acadians from Nova Scotia around 1759. Jay Street is at right, and Hempstead Street is at left. The home at left has been removed.

The Independent Order of Odd Fellows (IOOF) building was located at 205 Bank Street west of Pearl Street. It is now a parking lot. The IOOF held meetings at various locations in the New London area.

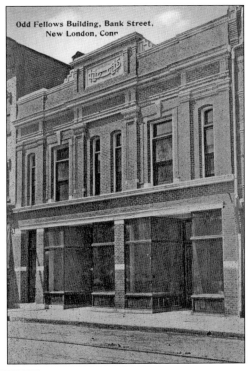

This postcard shows the Lyceum Theatre, located on Washington Street, which operated from the late 1800s until the late 1930s. Its orientation—between New York City and Boston—made it a popular testing ground for pre-Broadway plays. Many famous actors and touring companies brought plays to the Lyceum, including actor James O'Neill (famous for *The Count of Monte Cristo*), the father of playwright Eugene O'Neill (see page 87). The theater was extensively burned, possibly from an electrical fire, and was torn down in the 1950s. Today, a parking lot is located on the site.

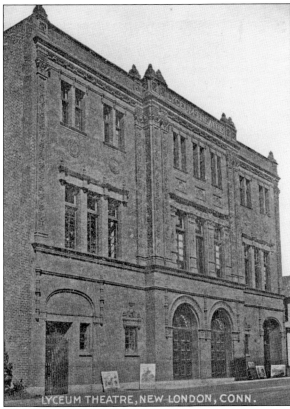

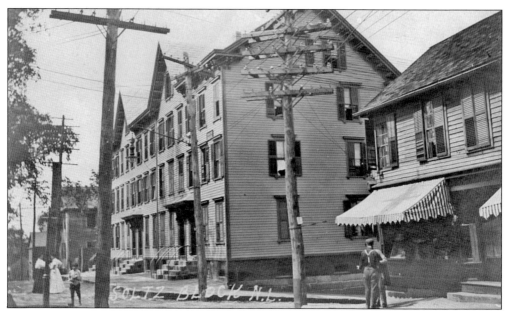

The house at 161–177 Bradley Street, on the corner of Douglas Street at the center of Soltz Block, sits due east of the Soldiers and Sailors Monument. Bradley Street was later renamed North Bank Street, and the house and street were both eliminated during redevelopment in the 1960s. (Courtesy of David Morrison.)

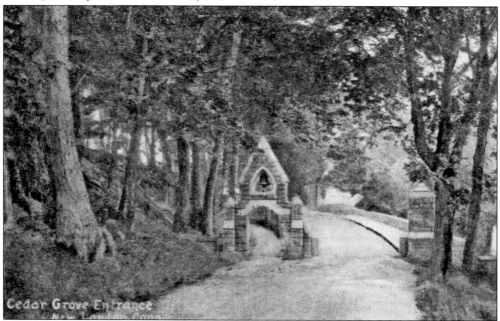

This, the "Chapell Entrance" (created in 1877), was once the main entrance (one of three entrances) into the Cedar Grove Cemetery. Mrs. Richard H. Chapell left it in perpetual trust with funds for the care and upkeep of burial plots and this entrance. It is located west of Colman Street and is no longer passable. The cemetery contains a monument honoring Civil War veterans, along with many impressive grave steles and obelisks bearing family names such as Allyn, Bacon, Chapell, Crocker, Daboll, Harris, Lawrence, Loomis, Rogers, Smith, Tait, Tinker, and Williams.

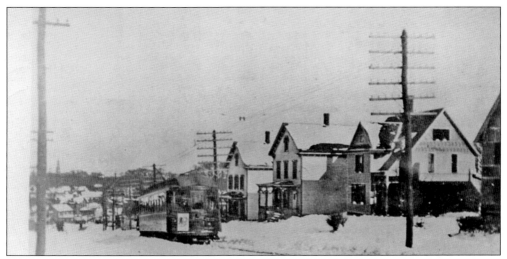

This trolley, running in a snowstorm at Town Hill near Summer Street, was headed toward Waterford. A trolley wait station (not shown) was located at Cedar Grove Cemetery's Broad Street entrance. The trolley wait station is now used as the visitors' center on Eugene O'Neill Drive and Golden Street. (Courtesy of David Morrison.)

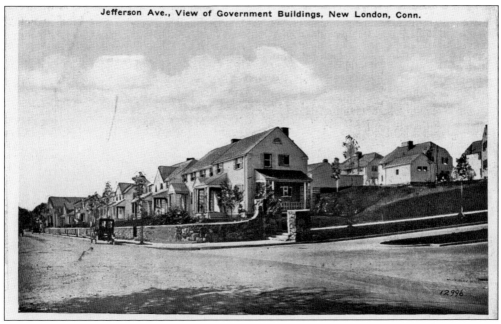

Jefferson Ave., View of Government Buildings, New London, Conn.

Jefferson Avenue is shown as a two-way street at the corner of Lincoln Avenue near the beginning of "the brick road." The house on the corner, the only one-family structure in the area, was used as a sales office for the houses that formed the US Housing Corporation in 1918. The corporation contained two-family homes with clapboard siding and slate roofs that housed families working for companies engaged in World War I efforts, such as Groton Iron Works, New London Ship and Engine Co. (now the Electric Boat Division of General Dynamics), railroads, Brainard & Armstrong Silk Mill, and Sheffield Dentifrice. After the war, veterans moved into the homes. This development was built under the guidance of architect Frederick Law Olmsted Jr.'s firm.

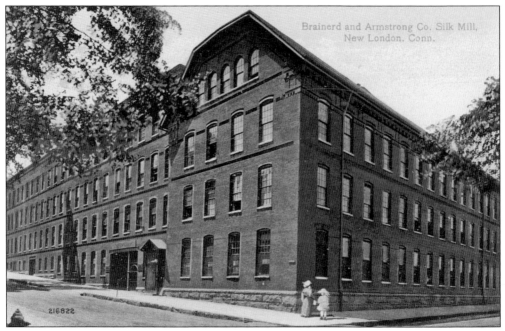

The Brainard & Armstrong Company Silk Mill, located at the corner of Church Street (now Governor Winthrop Boulevard) and Union Street, began operations around 1865. The firm had another mill in Norwich and over 1,000 employees. This mill was torn down during redevelopment in the 1960s, and the site now contains a parking garage. Fire hydrants (such as the one in the lower left corner) were installed around 1873.

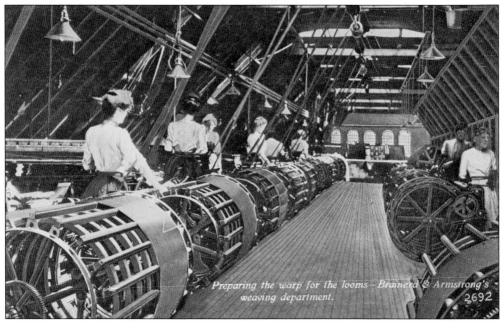

Women prepare the warp for the looms in the Brainard & Armstrong Company's weaving department.

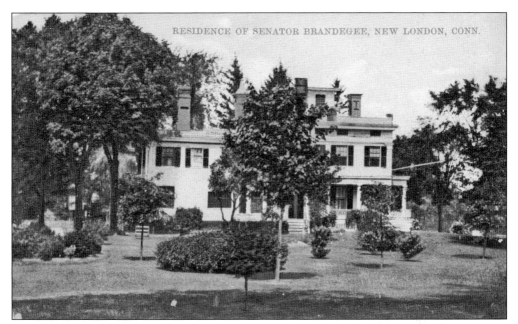

The Brandegee family mansion, built around 1840, was located in the Post Hill District on Hempstead Street, where a brick apartment house now stands on a cul-de-sac overlooking Interstate 95.

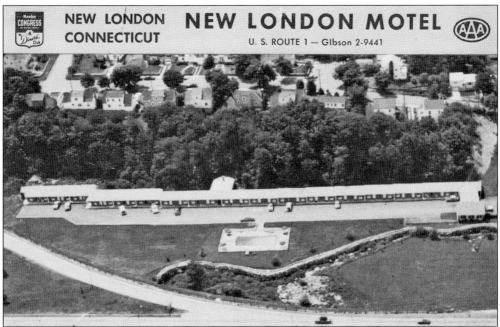

This postcard shows the New London Motel on US Route 1. It had 34 spacious units with televisions, air conditioning, and tile baths with showers. The motel had a swimming pool and offered free continental breakfast. This was demolished to make way for the expansion of the Gold Star Memorial Bridge. Beyond the frame at upper left is where the Post Hill Historic District begins near Beechwood Manor (see page 73).

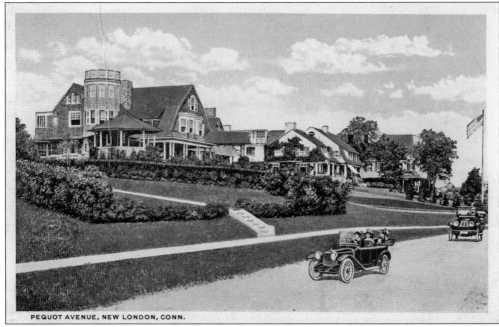

Among the families who lived in these homes near Jerome Road were Dimocks, Landers, Bliss, and Bragaw. Some of these houses have been replaced with more modern structures.

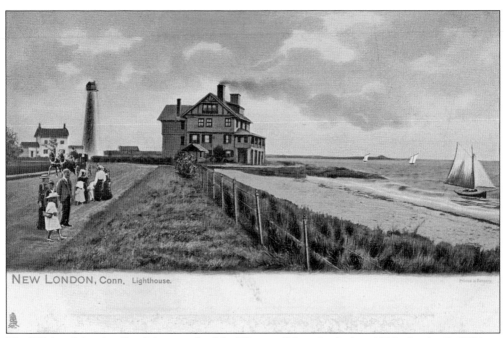

NEW LONDON, Conn. Lighthouse.

The Whiton Mansion faced the mouth of the Thames River. In the late 1800s, Lucius E. Whiton relocated from West Stafford to New London to start a machine shop on Howard Street near the corner of Walbach Street. The New London Harbor Lighthouse (left) was one of the first lighthouses built in Connecticut and was listed in the National Register of Historic Places in 1990. Benedict Arnold landed near these beaches to initiate his raid on New London in 1781.

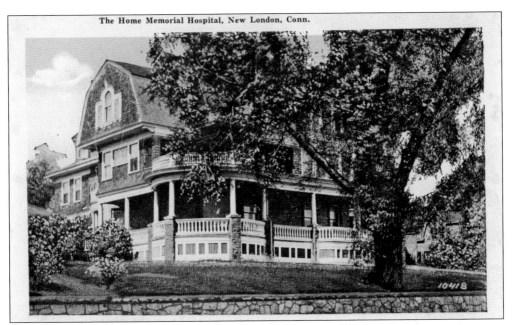

This house, at 361 Pequot Avenue, was constructed in 1868 as the home of John W. and Frances M. Emmons. It is now part of Mitchell College and known as "The Moorings" dormitory. This location is not far from playwright Eugene O'Neill's boyhood summer home, the Monte Cristo Cottage; both structures overlook the Thames River. No information has been discovered that validates the "Home Memorial Hospital" label on this postcard.

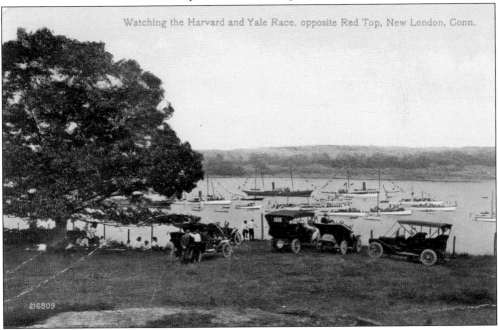

Watching the Harvard and Yale Race, opposite Red Top, New London, Conn.

These spectators are watching the Harvard and Yale regatta. According to the Harvard Athletics website, the regatta came to New London in 1878 and had an initial crowd of around 25,000. The races started elsewhere in 1852. By 1925, the race attracted more than 100,000 spectators, including passengers who arrived on two trains specifically chartered for regatta viewers.

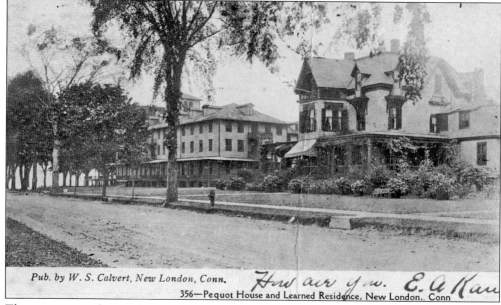

Pub. by W. S. Calvert, New London, Conn.

How are you. E. A. Kar

356—Pequot House and Learned Residence, New London., Conn

The summer residence of the Learned family (right), built around 1870, was removed in the early 1930s. A new home was built by Connecticut lieutenant governor Ernest E. Rogers and today has the address of 605 Pequot Avenue. At left is the Pequot Hotel (also referred to as the Pequot House), located at the corner of Pequot and Glenwood Avenues. (Courtesy of David Morrison.)

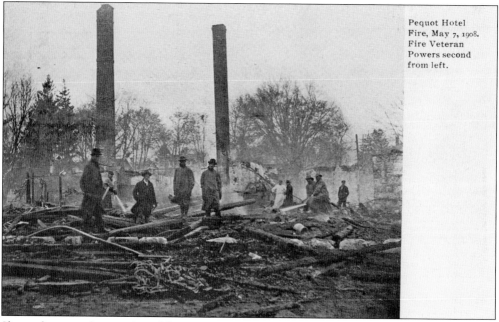

Pequot Hotel Fire, May 7, 1908. Fire Veteran Powers second from left.

Shown here are the remains of the Pequot (House) Hotel following a fire in 1907. The Pequot House, as it was referred to locally, served as the summer headquarters for the New York Yacht Club. The hotel never reopened after the fire. (Courtesy of David Morrison.)

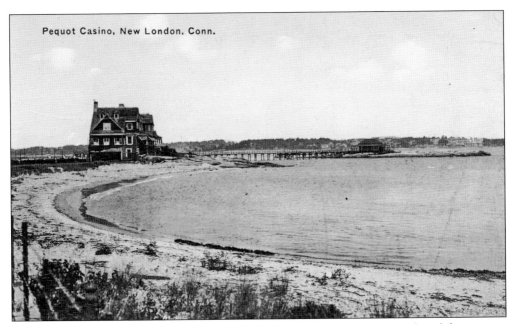

Pequot Casino, New London, Conn.

The Pequot Casino Association, a very exclusive club organized in 1890, purchased the summer home of William C. Shermerhorn and called it the Pequot Casino. They added the pier at a later date. Prior to 1917, the structure endured several fires, and it was rebuilt each time. The structure has been separated and is now two separate residences.

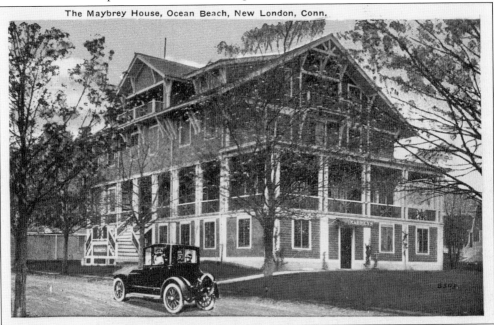

The Maybrey House, Ocean Beach, New London, Conn.

The Mabrey Hotel, open year-round and located just outside Ocean Beach on Park Street, was a place where guests could enjoy dancing, a cocktail room, a taproom, and fine dining. The hotel was advertised as being "on the Sound," with large porches and running water in all rooms. Milk and vegetables came from the hotel's own farm. It has been remodeled several times since this photograph was taken in the early 1900s. (Courtesy of David Morrison.)

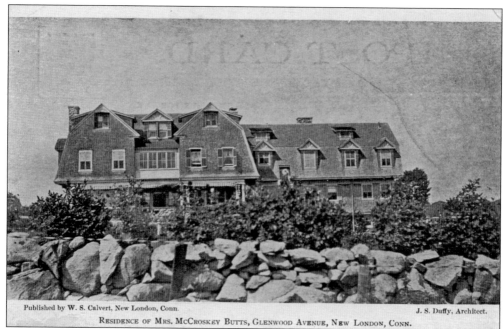

Published by W. S. Calvert, New London, Conn. J. S. Duffy, Architect.

RESIDENCE OF MRS. McCROSKEY BUTTS, GLENWOOD AVENUE, NEW LONDON, CONN.

Rockacres, located at 210 Glenwood Avenue, between Lower Boulevard and Ocean Avenue, was the home of Mr. and Mrs. Havemeyer Butt. It was in the Holly Terrace area, where new houses were constructed in the 1950s.

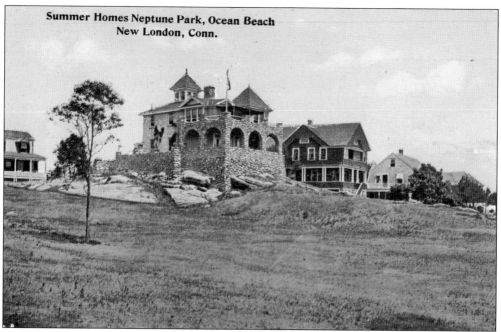

The distinctive arched stone porch marked the property at 11 Elliott Avenue, the Thomas M. Waller home, built around 1860. It was in the area known as Neptune Park. Waller was mayor of New London from 1873 to 1879, secretary of state from 1870 to 1871, and governor of Connecticut from 1883 to 1885. He died in 1924.

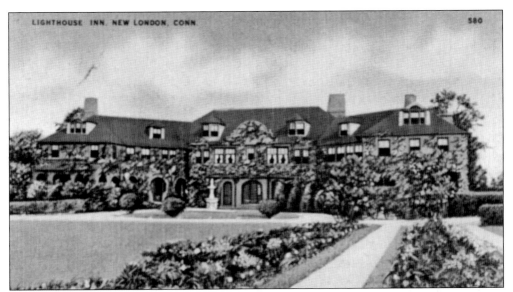

Lighthouse Inn, on North Guthrie Place, was once known as Meadow Court. The structure was built around 1902 as the summer home of Charles S. Guthrie, chairman of the Republic Iron & Steel Company. It was converted into an inn around the 1930s. In 1996, it was listed in the National Register of Historic Places. The original grounds were landscaped by the Frederick Law Olmsted firm. In 1979, a fire destroyed much of the inn, which required rebuilding.

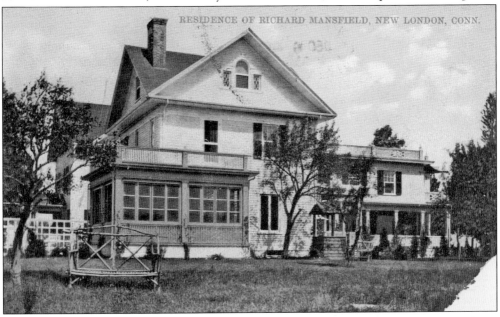

The home of Richard Mansfield (1857–1907) was located at 715 Ocean Avenue. Mansfield was born in Germany and performed many times at the Lyceum Theatre (see page 75). Across the street, at 712 Ocean Avenue, Mansfield; his wife, Beatrice Cameron (1866–1940); and their son Richard II are buried in the Gardner cemetery. Richard II enlisted in the Army the day he learned that his best friend, Jack Morris Wright, fell from an airplane and died in France on January 24, 1918; the Mansfields recognized Wright with a cenotaph in the cemetery. Richard II died on April 3, 1918.

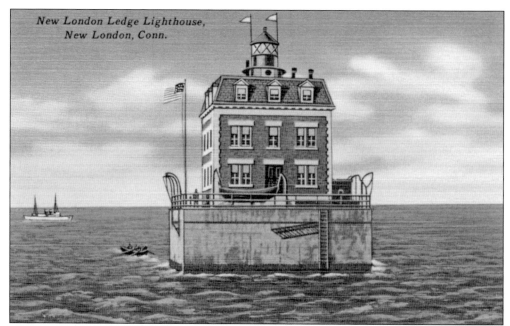

New London Ledge Lighthouse, New London, Conn.

T.S. Scott built the Ledge Lighthouse at the mouth of the Thames River around 1909 to warn ships about the nearby Black Ledge and Southwest Ledge. The base of the lighthouse was constructed with concrete and steel. The light, which can be seen for 13 miles when there is total visibility, was activated on November 10, 1909. The US Coast Guard maintained it until recently, when the New London Maritime Society took over its care with support from the New London Ledge Lighthouse Foundation. It was listed in the National Register of Historic Places in 1990.

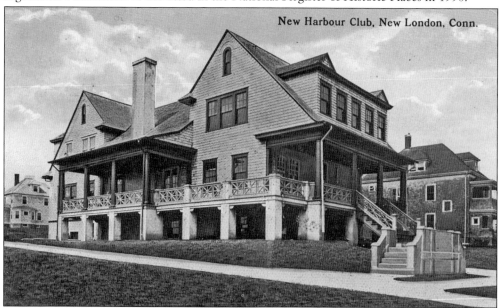

New Harbour Club, New London, Conn.

The Harbour Club (or New Harbour Club) stood at 355 Montauk Avenue, at the corner of Faire Harbour Place. The building permit for this structure was issued in 1912. The club soon changed its name to the Faire Harbour Club. This building was removed in the 1980s for the expansion of the Lawrence & Memorial Hospital parking garage.

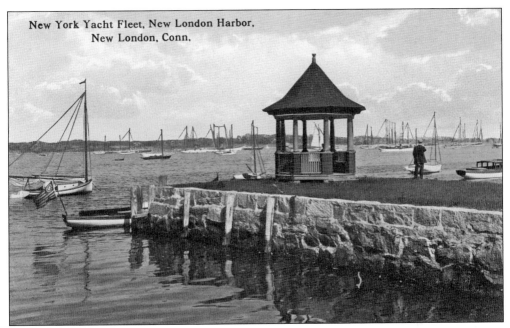

New York Yacht Fleet, New London Harbor,
New London, Conn.

This postcard shows the stone- and earth-filled pier, with an observation gazebo, that was across the street from the Pequot House Hotel (see page 82). It catered to the boating needs of the wealthy summer residents of the Pequot Colony. This pier became the scene of great outings during the Yale-Harvard regattas.

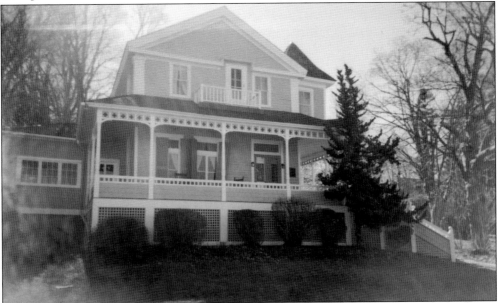

The Monte Cristo Cottage, designated a National Historic Landmark in 1971, was the boyhood home of American playwright Eugene O'Neill. This home, which overlooks the Thames River from Pequot Avenue, was the setting for O'Neill's plays *Long Day's Journey into Night* and *Ah, Wilderness!* His father, touring actor James O'Neill, made his fortune by purchasing the rights to *The Count of Monte Cristo* and performing its leading role at venues across the country. (Photograph by Catherine Keating.)

This home at 806 Montauk Avenue, called Hall Cottage, was part of Pequot Colony. It was built in 1875 and moved to this site in 1901. (Photograph by Ann Marie Keating.)

Sea View Cottage was built as part of Pequot Colony at the corner of Hall Avenue and Chapel Drive in 1878. (Photograph by Ann Marie Keating.)

This home at 35 Hall Avenue, called Ten Pin Alley, was part of Pequot Colony. It was built around 1866 and moved to this site in 1872. (Photograph by Ann Marie Keating.)

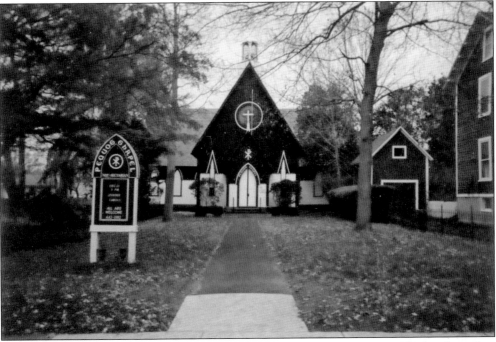

The Pequot Chapel, located at 857 Montauk Avenue, was built in 1871 to provide church services for people of the Pequot Colony, a summer colony in the southern part of New London. The Gothic Revival building has two stained-glass windows created by Louis Comfort Tiffany. (Photograph by Mary Keating.)

At farthest left is the Kelo House, part of a landmark 2005 US Supreme Court case. The court ruled that the city could use eminent domain to take the homes shown here and give the land to a private entity for "economic development." This decision led to over 40 states reforming legislation in favor of property owners. The Kelo House, also known as the "Little Pink House," was relocated to 36 Franklin Street with a granite post engraved "Not for sale." All the homes shown here (located on Walbach Street) and all the homes that were part of the Fort Trumbull neighborhood were demolished. The land remains undeveloped. (Photograph by Lawrence Keating.)

This view shows Garfield Avenue, which runs from Williams Street across Connecticut Avenue, then goes across Jefferson Avenue before ending at Colman Street. This view is looking west. Memorial Hospital (see page 92) is in the far background at upper right.

Five

HOSPITALS

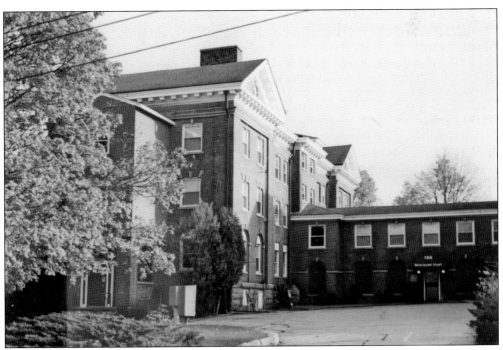

These buildings, located at 156 Garfield Avenue, are now part of a condominium complex called Briarwood Court. The granite and brick structures were once an almshouse started with a donation from New London businessman Jonathan Newton Harris. The Mitchell Isolation Hospital (not shown) was located west of this area at Colman Street and Garfield Avenue. Annie Olivia Tiffany Mitchell, who donated $100,000 to care for patients with tuberculosis and smallpox, was the patron of the isolation hospital. These buildings are part of the Civic Institutions Historic District, which was listed in the National Register of Historic Places in 1990. (Photograph by Lawrence Keating.)

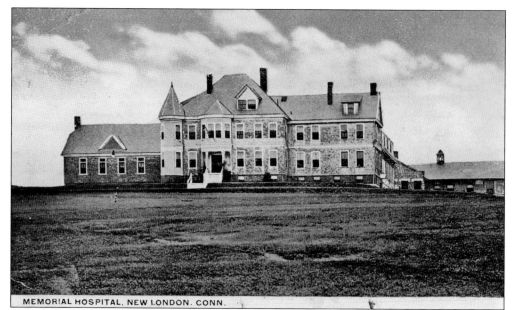

MEMORIAL HOSPITAL. NEW LONDON. CONN.

Memorial Hospital, located at 163–171 Garfield Avenue, was built around 1892 thanks to a donation from patron Jonathan Newton Harris, a wealthy businessman who contributed to the construction of the almshouse for the poor and this hospital. In 1918, this served as a US Naval Hospital for Marines. Today, only the middle building (with the tower section) is still standing; it is an apartment house facing Jefferson Avenue. Behind this apartment house is a side-by-side duplex, 173–175 Garfield Avenue, with a plaque reading "Lawrence & Memorial 1892."

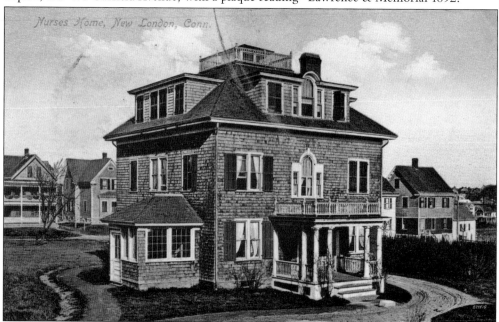

Nurses Home, New London, Conn.

The Nurses' Home (or dormitory) at 163 Garfield Avenue opened around 1901. Today, the entrance is on the opposite side, and its address is 32 Walden Avenue. The roofline of the houses in the background is still visible today. Memorial nurses have had living quarters in various locations, including at 27 Manwaring Hill, 342–344 Montauk Avenue, and 350 Ocean Avenue.

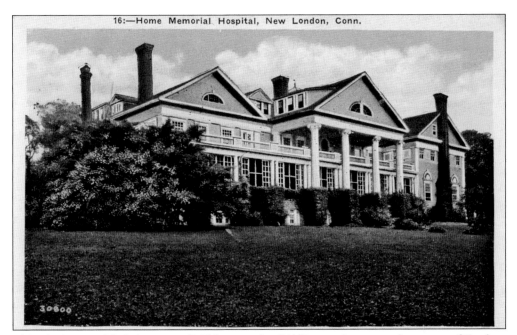

16:—Home Memorial Hospital, New London, Conn.

This, the home of Col. Augustus G. Tyler, stood at 541 Pequot Avenue at the corner of Gardner Avenue. The house, also called The Elms, was the scene of many parties when the Pequot Colony was at its peak of popularity. The house, which later became Home Memorial Hospital, was destroyed by fire in 1944.

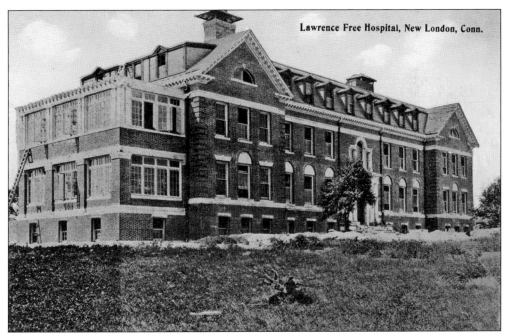

Lawrence Free Hospital, New London, Conn.

The Lawrence Free Hospital, built at 365 Montauk Avenue, was established in 1912. In 1930, it merged with the Manwaring Hospital, which was located on Garfield Avenue.

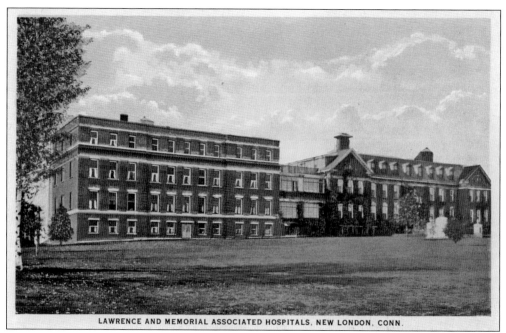

LAWRENCE AND MEMORIAL ASSOCIATED HOSPITALS, NEW LONDON, CONN.

The Lawrence and Memorial Associated Hospitals are pictured here after the two hospitals combined resources in 1912.

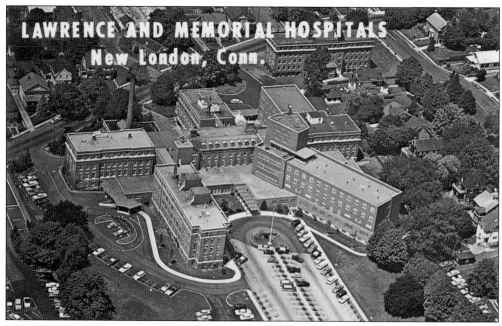

This photograph, facing Montauk Avenue, was taken after 1960, the year of the $4 million expansion and modernization of the nonprofit Lawrence & Memorial Hospital, which contained 311 beds and 58 newborn bassinets. The Nanine Lawrence Pond House facing Ocean Avenue (at upper right), which once contained the Nurses' Home, is now the in-patient psychiatric wing. It was started in part with funds from a relative of the Lawrence family. The L&M Hospital has since expanded, resulting in the removal of many homes shown on the right side of this postcard.

Six

PARKS AND
FORT TRUMBULL

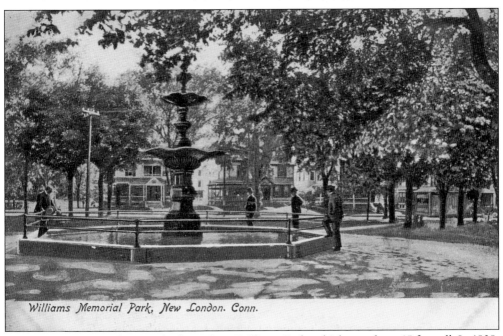

Williams Memorial Park, New London. Conn.

This c. 1906 postcard features the fountain at Williams Park, which was about 15 feet tall. In 1838, Gen. William Williams purchased the park for $6,700 and donated it to the city in memory of his son, who had died suddenly. The fountain, built in 1873, was a gift from wealthy homeowners living around the park. The Nathan Hale statue replaced this fountain in 1935.

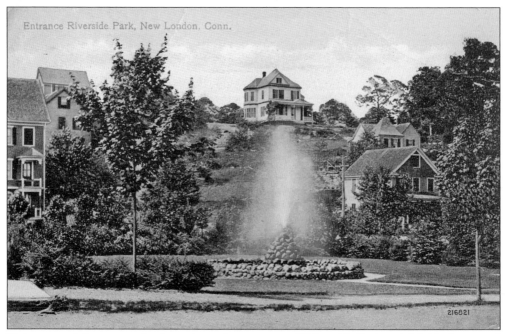

This postcard focuses on the fountain at the entrance of Riverside Park at Adelaide Street and Crystal Avenue. It also shows how hilly the area was near the fountain. The large house in the background at center was the McQuire home, located at the corner of Bolles Avenue and Rosemary Street. This fountain is no longer in existence.

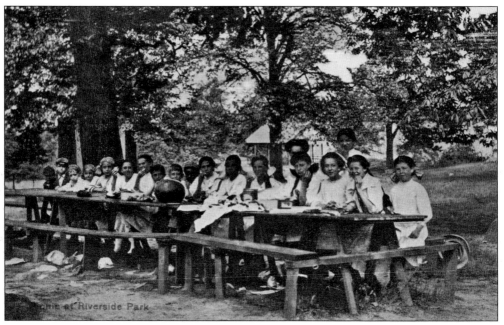

This c. 1905 postcard shows a neighborhood outing at Riverside Park.

Williams Memorial Park was once known as the Second Burial Ground. The bodies at Second Burial Ground were exhumed around 1850 and reinterred in what is now Cedar Grove Cemetery (see page 76), which opened around 1852. The removal of the bodies allowed for this land to be opened for public use. This postcard is labeled "Hempstead Park" because the park, located at the corner of Hempstead and Broad Streets, is sometimes referred to as such. Williams Memorial Park Historic District was listed in the National Register of Historic Places in 1987.

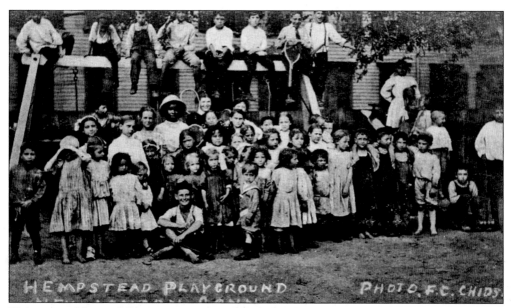

This postcard shows children posing at a neighborhood playground. (Courtesy of David Morrison; photograph for this postcard by F.C. Chidsey.)

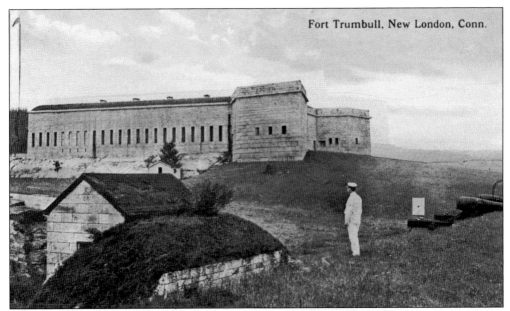

Fort Trumbull is named for former governor Jonathan Trumbull, the only governor of the 13 colonies who was elected, not appointed by the king. Note the height of the flagpole at far left. The Egyptian Revival–style granite fort was built from stone quarried at Millstone Point between 1839 to 1852 as part of a federal coastal fortification system after the War of 1812. At right (South Battery) is a row of cannons. There are touchable Rodman guns in today's state park, and an interactive tour is available at 90 Walbach Street. Fort Trumbull was added to the National Register of Historic Places in 1972.

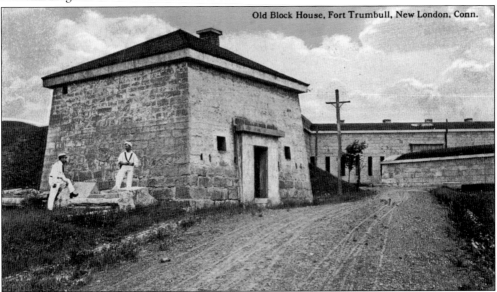

Old Block House, Fort Trumbull, New London, Conn.

This c. 1915 postcard looks south into Fort Trumbull with the Block House in the foreground. This Block House, built as part of a 1794 federal fortification program, has a square design with hip roofs and rifle slits, is made of granite, and has a brick chimney. Block houses, also referred to as citadels, were used as a place where soldiers could access ammunition stored for use in last-ditch efforts to repel the enemy.

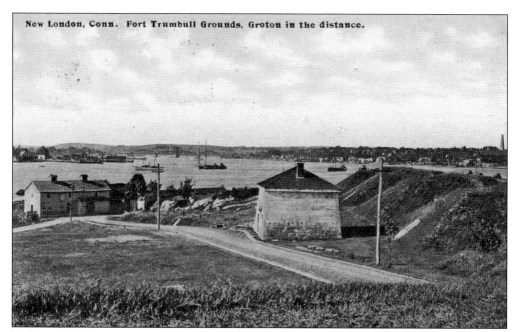

New London, Conn. Fort Trumbull Grounds, Groton in the distance.

In this c. 1920 image looking north on the Thames River, the Groton Monument is visible in the far distance at far right. The electromagnetics division of the Naval Underwater Sound Laboratory used this site to test equipment for submarines. In 1839, captives aboard the *Amistad* lay anchored off Fort Trumbull before being transferred to another ship bound for New Haven.

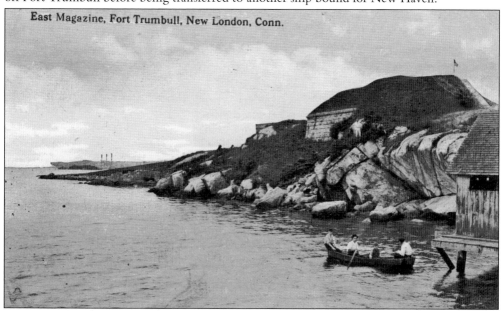

East Magazine, Fort Trumbull, New London, Conn.

This c. 1912 postcard shows the East Magazine at Fort Trumbull. The classrooms at Fort Trumbull, in Maury Hall (later known as Building 28), were used to host the largest US Maritime Service Officers School prior to and during World War II. Nearby memorials pay tribute to its veterans and to Capt. Moses Rogers, of New London, who skippered the *Savannah*, the first steam-propelled ship to cross the Atlantic. The US Coast Guard had an academy here until 1932, when the academy moved upriver to its new campus on Mohegan Avenue (see page 123).

Fort Trumbull is shown in the foreground of this north-facing postcard. The long building at lower left is where "clam shuckers" (shown in the below postcard) worked. The steeple of the First Congregational Church is just left of center in the background. The Mohican Hotel is visible to the left of the steeple. The steeple at far left belongs to the Second Congregational Church.

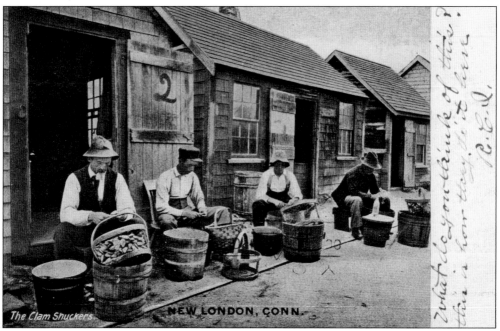

The Clam Shuckers. NEW LONDON, CONN.

The term "clam shucker" evolved into "clam digger" and eventually became nearly derogatory. This building, shown around 1905, was located between East Street and the Thames River.

Seven

WORSHIP

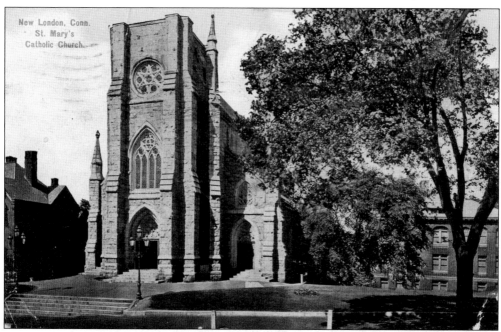

St. Mary Star of the Sea Church is located at 10 Huntington Street. It was designed by Patrick Keeley and completed in 1876. It is built of granite in the Gothic Revival style. This postcard shows the church without its steeple. The steeple was completed in 1911 using funds designated in the will of Sebastian D. Lawrence. To the south (left) is the rectory; the brick building to the north (right) is St. Mary School, run by the Sisters of Mercy. The stone for the steeple was quarried from Bates Woods in New London. The steeple bells rang for the first time on March 31, 1935.

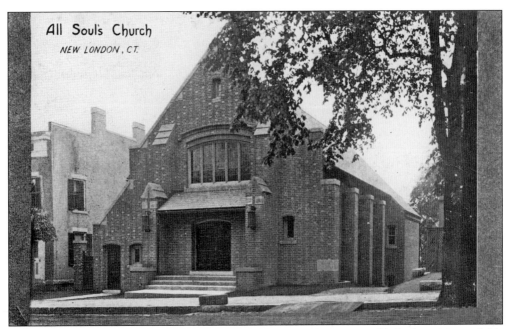

The congregation of All Souls Church (Unitarian Universalist) was established in 1907, and this church, located at 60 Huntington Street, was built in 1910. The stained-glass Tiffany window, entitled "Come Unto Me," was installed in 1924 and was a gift from Mrs. Edward Hammond in memory of her mother, Anna Chapin Rumrill. In 2014, the window became part of a collection at the Lyman Allyn Art Museum after the congregation departed from this building.

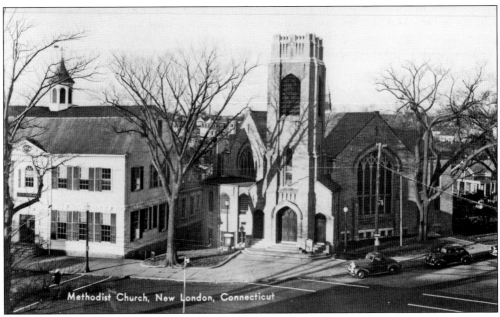

This postcard shows the United Methodist Church, located at Huntington and Broad Streets next to the State of Connecticut Superior Court. The church relocated here in 1921, then moved to its current location at 130 Broad Street (see page 117). Methodism arrived in Connecticut around 1789. The new extension of the courthouse has replaced the church structure.

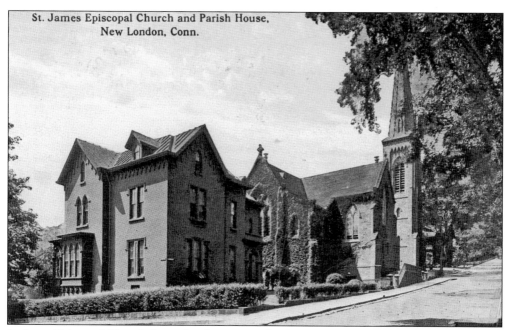

St. James Episcopal Church and Parish House,
New London, Conn.

St. James Episcopal Church, located at the corner of Federal and Huntington Streets, was designed by architect Richard Upjohn in the Gothic Revival style. Construction began in 1847, and the building was consecrated in 1850. It is known for its stained-glass windows, several of which were created by Louis Comfort Tiffany. The J&R Lamb window commemorates two friends who died in World War I. The church is also famous as the burial place of Samuel Seabury (1729–1796), the first bishop of the Episcopal church in the United States and rector of St. James Church in New London. Seabury is buried in the Hallam Chapel of the current church. The rectory in the foreground is no longer standing.

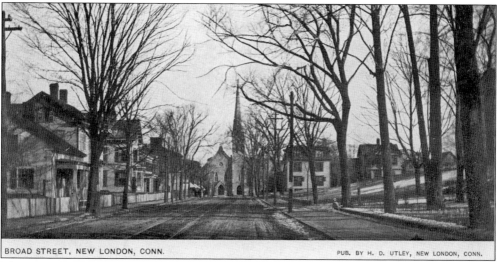

BROAD STREET, NEW LONDON, CONN.
PUB. BY H. D. UTLEY, NEW LONDON, CONN.

This east-facing postcard of Broad Street highlights the Second Congregational Church (center background), located at the corner of Broad and Hempstead Streets. It was built in 1868 in the Gothic style. In the 19th and 20th centuries, many prominent New London business leaders attended this church, which suffered a major fire in 1926. It is now occupied by Miracle Temple. Most of the trees lining the street in this postcard were destroyed in the 1938 hurricane.

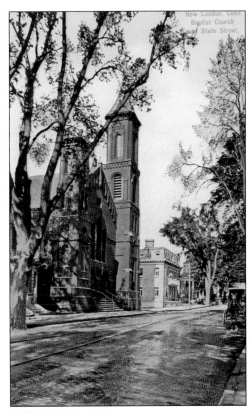

The architecture of the First Baptist Church, built in 1856, is reflective of the Victorian period. The church, located on State Street, was designed by W.T. Hallett. The stained-glass windows were funded by families who belonged to the church. This church was listed in the National Register of Historic Places in 1979.

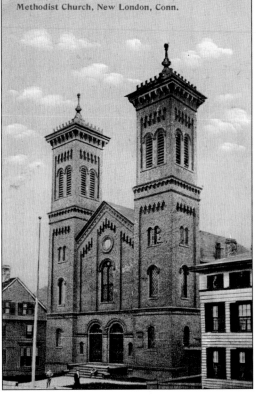

This postcard shows the United Methodist Church at 54 Federal Street. The double-tower building, erected in 1855, held services until 1921, when the congregation relocated to Huntington Street (see page 102). In 1924, Congregation Ahavath Chesed bought the building. The top thirds of both bell towers were removed, leaving the towers level with the roofline. This house of worship was removed during the 1960s redevelopment, and the site is now the Holiday Inn parking lot.

The First Congregational Church is located at the corner of State and Union Streets. The congregation has been part of the New London community since 1642, when the First Church of Christ Congregation was organized. In 1787, an edifice was erected on this site. In 1850, the current church (shown on this postcard) replaced the previous structure. It is built in the Gothic Revival style and was designed by architect Leopold Eidlitz. This church was listed in the National Register of Historic Places in 1979.

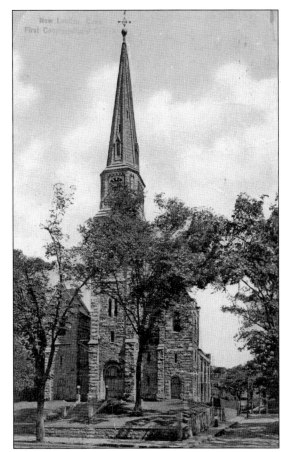

The Universalists dedicated this building at 157 Green Street in 1882 and sold it to the Brainard Lodge of Masons in 1896. It was built in the Romanesque Revival style by John and Charles Bishop. Today, it is an active church—the Apostolic Cathedral of Hope. Prior to 1835, the Starr Street Ropewalk, a long, shed-like building where workers made hemp into rope, stood to the left of this structure. After a fire in 1832, John Bishop populated Starr Street with Greek Revival and Italianate homes that were restored starting in 1981.

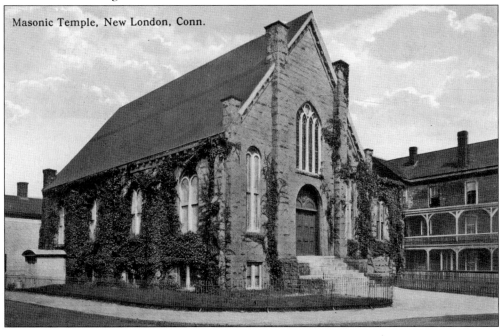

Masonic Temple, New London, Conn.

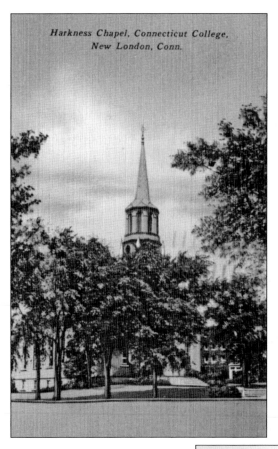

Harkness Chapel, Connecticut College,
New London, Conn.

The description on the back of this postcard reads, "Harkness Chapel, located on the campus of Connecticut College, was built in 1940 as the gift of Mrs. Mary Stillman Harkness (of Waterford, CT and New York)." (Photograph of this postcard by Wm. C. Peck.)

The Ohav (or Ohev) Sholem Synagogue occupied this building, erected around 1919 at 109 Blinman Street, which was listed in the National Register of Historic Places in 1995. Today, the Centro de la Comunidad occupies this building. (Photograph by Ann Marie Keating.)

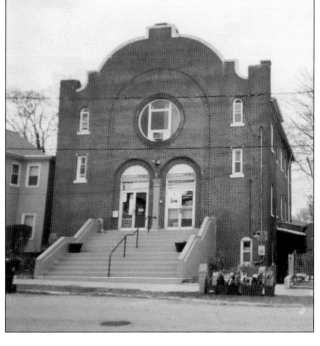

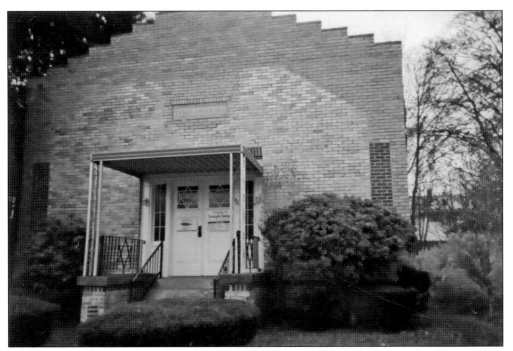

Temple Israel, located at 73 Park Street, was constructed in 1925 to handle a sizeable recurring summer crowd. (Photograph by Ann Marie Keating.)

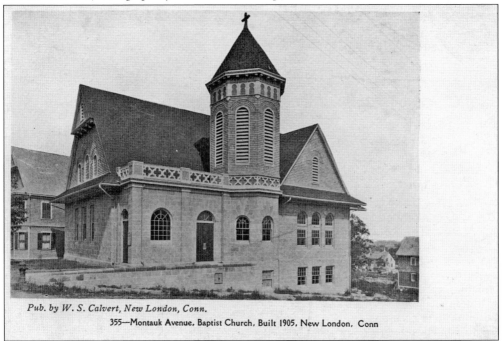

Pub. by W. S. Calvert, New London, Conn.

355—Montauk Avenue, Baptist Church, Built 1905, New London, Conn

After a fire in April 1917, the Montauk Avenue Baptist Church was rebuilt as the structure shown here. It moved to this site, at 236 Montauk Avenue, in 1905. Prior to this, the congregation was called the Second Baptist Church, had formed in 1840, and was on Union Street. It is now occupied by the Calvary Chapel of Southeastern Connecticut and also Tabernacle of Faith Church.

The Polish National Church was built in 1924 at 730 Main Street. It is now the location of the New London Hospitality Center. (Photograph by Ann Marie Keating.)

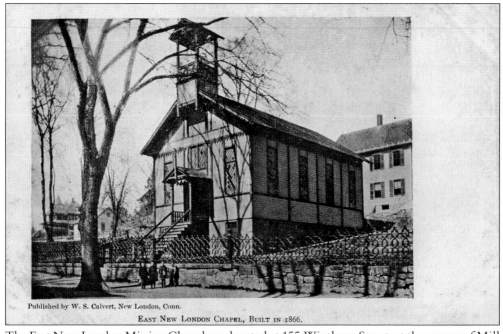

Published by W. S. Calvert, New London, Conn.

EAST NEW LONDON CHAPEL, BUILT IN 1866.

The East New London Mission Chapel was located at 155 Winthrop Street, at the corner of Mill Street. It was built in 1891; in 1917, it was sold to the Tait Brothers, who opened an ice-cream plant in the building. The Old Town Mill (not shown; see page 2) is to the front and left of this site. Today, a large concrete column of the Gold Star Memorial Bridge is just to the right of where this chapel stood before it was torn down.

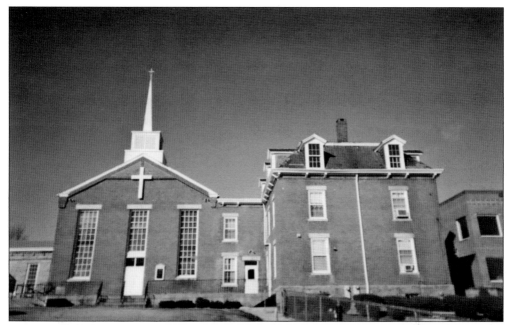

This is a modern picture of Shiloh Baptist Church, located on Garvin Street. It had been in a much smaller wooden building near this location since 1894. This has been a racially diverse area since the early 19th century, when abolitionist Savillion Haley built and sold several houses for black families. Haley and William Bolles were arrested in 1842 for antislavery activities. (Photograph by Ann Marie Keating.)

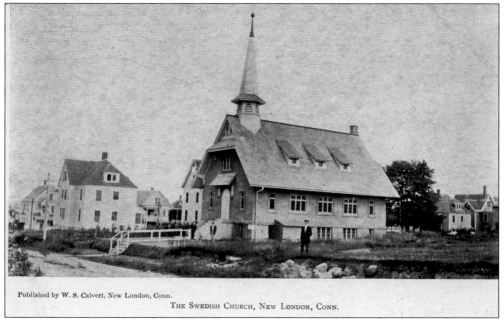

Published by W. S. Calvert, New London, Conn.

THE SWEDISH CHURCH, NEW LONDON, CONN.

In 1907, this chapel at 14 Linden Street became home to the Swedish Evangelical Society. Prior to 1907, the congregation had been worshiping in a building where black worshipers gathered—the AME Zion Church on the corner of Ocean Avenue at Bank Street. A gas station replaced the AME Zion Church around 1930.

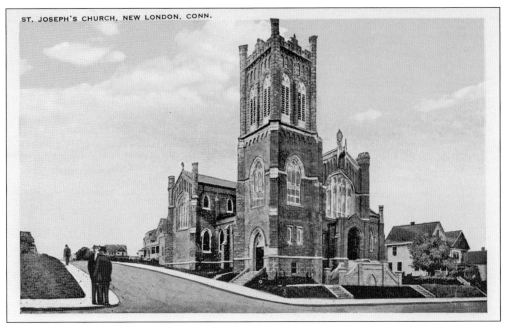

This postcard shows St. Joseph Roman Catholic Church, located at the corner of Montauk Avenue and Squire Street. It was built by the Ryan Company in 1909 in the Romanesque/Gothic style. Prior to the building of this structure, parishioners went one block south, near the corner of Linden Street, to attend mass at St. Joseph Chapel. The chapel is no longer in existence.

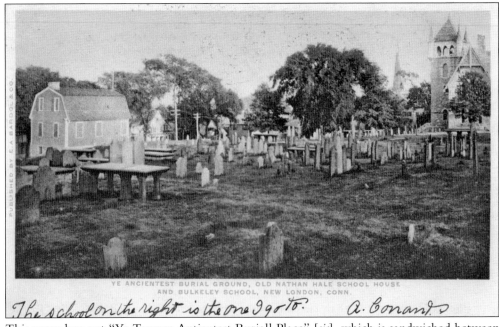

YE ANCIENTEST BURIAL GROUND, OLD NATHAN HALE SCHOOL HOUSE
AND BULKELEY SCHOOL, NEW LONDON, CONN.

The school on the right is the one I go to. A. Conant

This scene lays out "Ye Townes Antientest Buriall Place" [*sic*], which is sandwiched between Hempstead and Huntington Streets and dates to around 1652. Some of the oldest known graves of black colonists are located here. At far left is the Nathan Hale Schoolhouse, and at far right is Bulkeley School. The graves with flat, table-like tops were generally reserved for deceased clergymen.

Eight

SCHOOLS

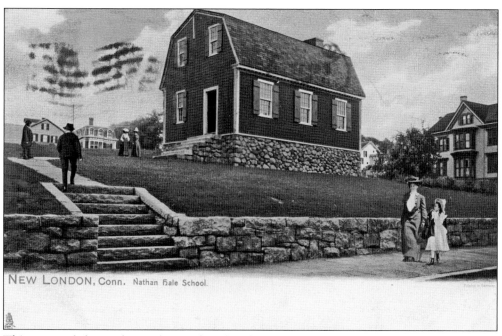

NEW LONDON, Conn. Nathan Hale School.

This postcard shows the Nathan Hale Schoolhouse when it was located at the "Ye Townes Antientest Buriall Place" [*sic*] on Huntington Street. Nathan Hale taught at this school when it was located on Union Street in 1774–1775 (see page 16). The schoolhouse has been moved several times from its original location and now stands on Atlantic Street near the Parade in downtown New London. It has previously been located near the old Winthrop School on Union Street, three times on State Street, and twice on Atlantic Street.

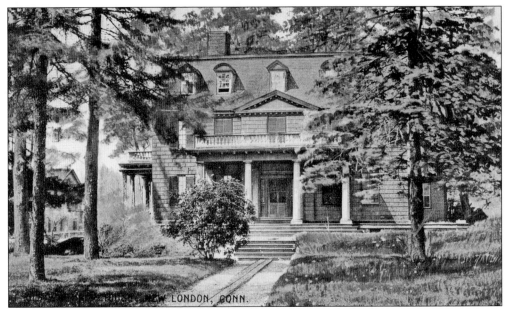

The Winthrop House was located on Mill Street, next to the Old Town Mill. It was designed by Peter Harrison, one of the first architects in the United States, and built in 1750–1752 by John Still Winthrop, the great-grandson of John Winthrop, Jr., the founder of New London. In 1893, the Winthrop House was torn down and replaced with Winthrop School. The school was later demolished to make way for the expansion of the Gold Star Memorial Bridge.

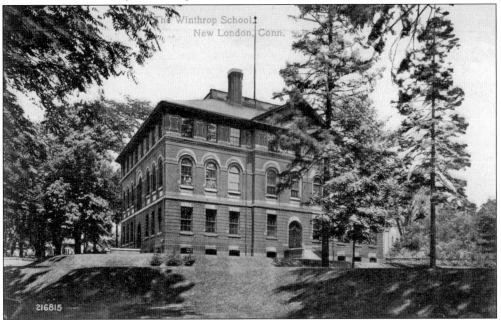

Winthrop School was built in 1893 for less than $30,000. It stood on Mill Street, next to the Old Town Mill, and was built on the site of the Winthrop House (shown above). The school was originally constructed as a two-story building; the third floor was added in 1901. This structure was demolished to make way for the expansion of the Gold Star Memorial Bridge, which connects New London and Groton.

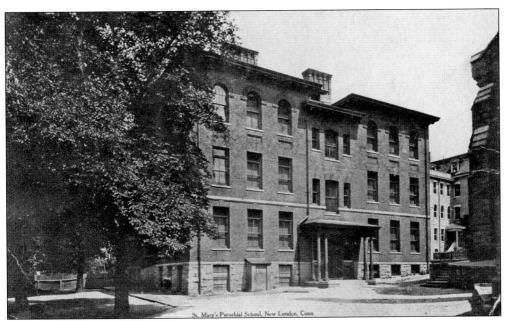

St. Mary School, at the rear of 28 Huntington Street, was built in 1898 and closed in 2014. This postcard dates to around 1910. The building to the right of the school housed the Sisters of Mercy. At far right is the westernmost side of St. Mary Star of the Sea Church. In 1892, a small number of nuns arrived to teach young girls in the first elementary school (grades one through five).

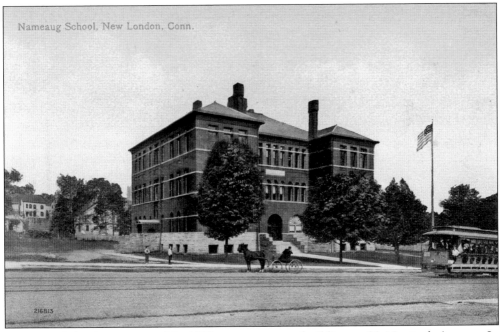

Nameaug School was erected in 1890 as a two-story building at 21 Montauk Avenue. In 1906–1907, the third story was added. Note the contrast in transportation in this image; trolleys began running in New London around 1892. Montauk Avenue, nicknamed "the Boulevard," was opened as a thoroughfare in 1891. This postcard dates to around 1918.

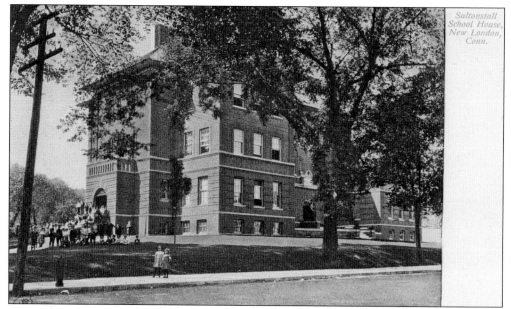

Saltonstall Grammar School, located at 106 Truman Street at the corner of Hempstead and Truman Streets, was built in 1903 in the Second Renaissance Revival style. It later became the Satti Building. This postcard dates to around 1910. Gurdon Saltonstall, who graduated from Harvard Divinity School in 1684, was the pastor of the First Church of Christ and served as the governor of Connecticut from 1708 to 1724.

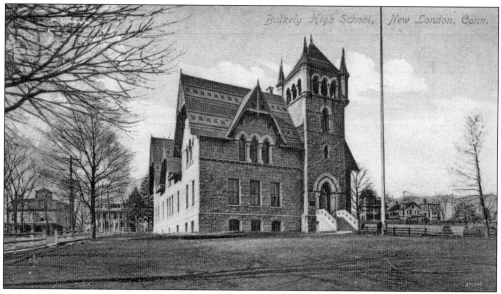

This postcard shows the original, Gothic-style Bulkeley High School for boys, which was designed by architect Leopold Eidlitz. It was built in 1871–1875 and endowed by Leonard N. Bulkeley, who died in 1849. Many prominent leaders in the New London community were educated at this prestigious school. An indoor basketball court was installed in the 1930s. The high school closed in 1951, when New London opened the coeducational New London High School. This building was turned into Bulkeley Junior High School in 1952. It is now occupied by the Regional Multicultural Magnet High School and has been somewhat modified.

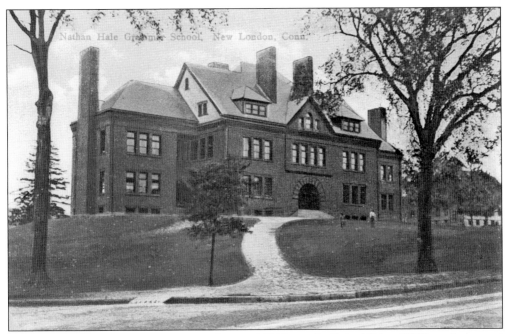

Nathan Hale Grammar School, pictured around 1912, was built in 1891 at Williams Street and the corner of Waller Street and Lincoln Avenue. It became part of New London High School in 1951. In 1993, it became part of Benny Dover Jackson Middle School.

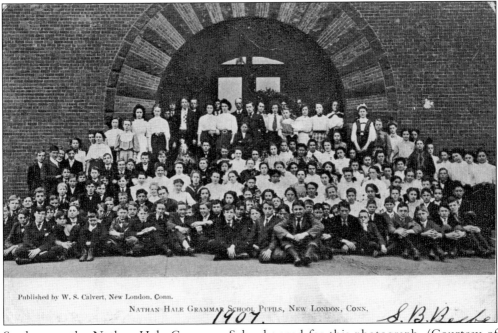

Students at the Nathan Hale Grammar School posed for this photograph. (Courtesy of David Morrison.)

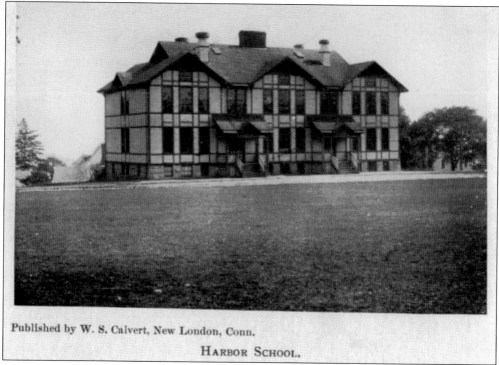

Published by W. S. Calvert, New London, Conn.

HARBOR SCHOOL.

This c. 1900 postcard shows the original Harbor School building in 1883. It was located at 432 Montauk Avenue, between Converse Place and School Street. The building was replaced around 1907.

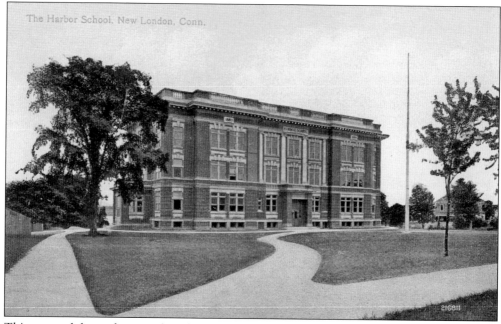

The Harbor School, New London, Conn.

This postcard shows the second Harbor School, built around 1907. It now has an addition on the north side. It is now called The Early Childhood Center at Harbor School and accommodates kindergarten students in the city of New London.

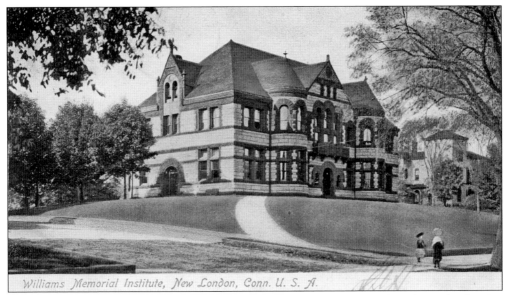

Williams Memorial Institute, New London, Conn. U. S. A.

This postcard shows the original Williams Memorial Institute (WMI), built in the Richardsonian Romanesque style, which opened in 1891 and was privately endowed by a trust fund from the estate of Harriet Pick Williams as a memorial to her son Thomas. It was a high school for girls until 1951, when the city opened the coeducational New London High School. In 1954, WMI moved to the Connecticut College campus, where it now operates as a coeducational college preparatory school under the name The Williams School. The State of Connecticut Superior Court Geographical Area (G.A.) 10 now operates from this building.

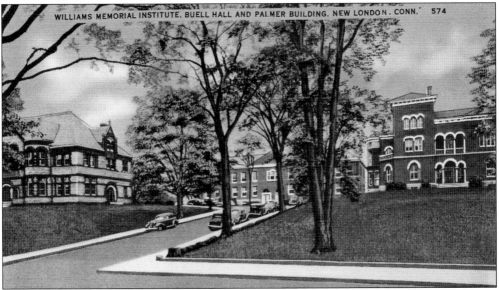

WILLIAMS MEMORIAL INSTITUTE, BUELL HALL AND PALMER BUILDING, NEW LONDON, CONN. 574

This postcard shows the former WMI campus, which later became St. Bernard High School for girls before finally becoming coeducational in 1958. The building at left is now the State of Connecticut Superior Court Geographical Area (G.A.) 10. At center is the Richard R. Martin Center/Senior Services Center. The building at right was a mansion that belonged to wealthy businessman Jonathan Newton Harris; he donated it for use as a place where wounded World War I soldiers could recuperate near their families. It now houses the United Methodist Church.

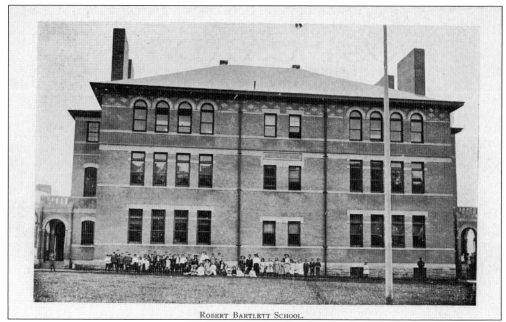

Robert E. Bartlett Grammar School, located at 216 Broad Street, was established in 1896. It started as an elementary school and, in 1951, merged with Nathan Hale Grammar School and Chapman Technical High School to create New London High School. This is now an office building.

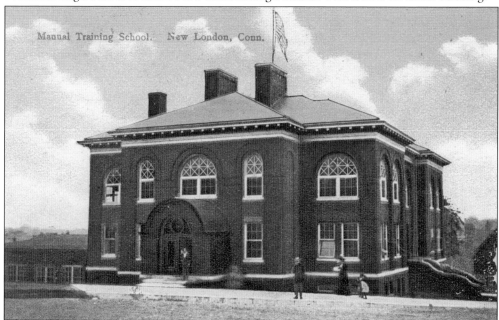

Chapman Technical High School was located at the corner of Waller Street and Connecticut Avenue. It was founded in 1906 by William H. Chapman and had several names over the years. It was originally called the Manual Training and Industrial School of New London, then New London Vocational High School, and, finally, Chapman Technical High School. In 1951, this building became part of New London High School. Due to code violations, the building was demolished in the 1990s. A marker is located at the building's former site.

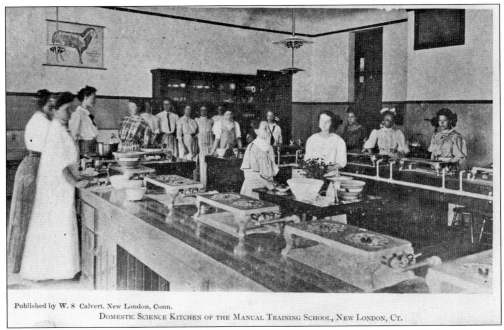

Published by W. S Calvert, New London, Conn.

DOMESTIC SCIENCE KITCHEN OF THE MANUAL TRAINING SCHOOL, NEW LONDON, CT.

These girls were photographed in the domestic science kitchen of the Manual Training and Industrial School of New London.

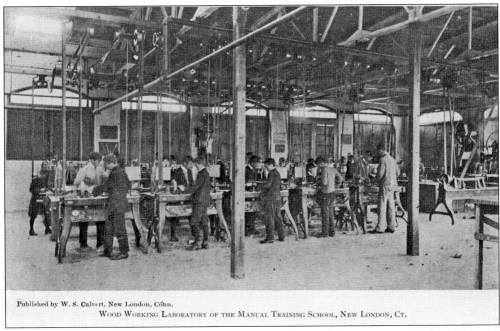

Published by W. S. Calvert, New London, Conn.

WOOD WORKING LABORATORY OF THE MANUAL TRAINING SCHOOL, NEW LONDON, CT.

These boys are pictured in the woodworking laboratory of the Manual Training and Industrial School of New London. (Courtesy of David Morrison.)

119

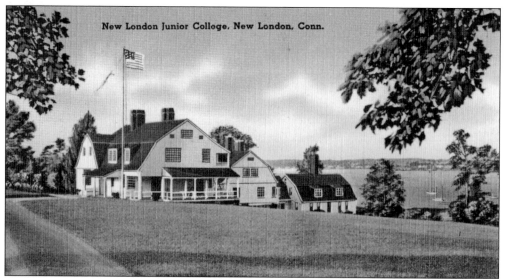

Mitchell Hall, once known as Sunflower Lodge, was the primary summer residence of Alfred Mitchell and his wife, Annie Olivia Tiffany Mitchell, who purchased the property—along with more than 40 acres of land—in the mid to late 1800s. In 1938, New London Junior College was established here; it was renamed Mitchell College in 1950. Other buildings of note (not shown) include The Ark (now the mail room), which was used by Mitchell's daughters Alfred and Charly as a playhouse. A monument to Nathan Hale can be found on the campus.

This wall lines part of the Montauk Avenue property of Mitchell College and was part of the original Mitchell estate. Across the street, on Montauk Avenue, is a retail ice-cream shop named Michael's Dairy, which is owned and operated by Mitchell College. Also across the street is the Frank S. Bond House, which was built in the Craftsman style in 1902; the college purchased it in 1958 for use as the school's library. (Photograph by Ann Marie Keating.)

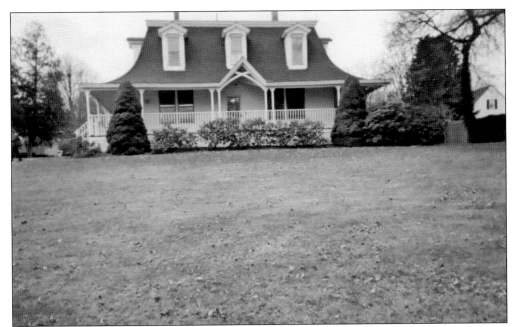

Alfred Mitchell and his wife, Annie Olivia Tiffany, built the Umbrella House in the 1880s to be used by family and guests. Louis Comfort Tiffany was Annie Mitchell's brother. The house, which features a sloping mansard roof, served as the residence of the president of Mitchell College for several decades. (Photograph by Ann Marie Keating.)

The Chappell Cottage (renamed the Alfred Mitchell Woods Field House) was built in 1932. Local granite was quarried for the construction of this Tudor Revival home. In 1931, Annie Olivia Tiffany Mitchell established the Alfred Mitchell Woods as a memorial to her husband. (Photograph by Ann Marie Keating.)

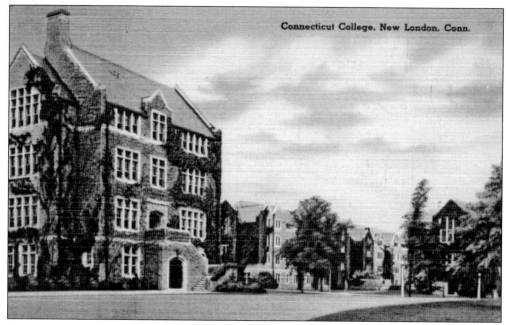

Connecticut College was chartered as a women-only school in 1911 (men were admitted starting in the 1960s) after a fundraising campaign by the citizens of New London, including wealthy real-estate businessman Morton Plant, who donated $1 million. Ewing and Chappell designed the first buildings, and the Olmsteds oversaw the landscaping. The college had its first female president, Katherine Blunt, in 1929.

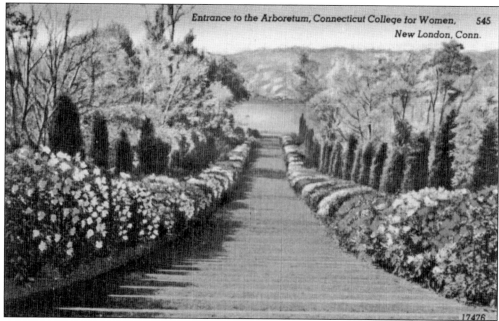

Entrance to the Arboretum, Connecticut College for Women, 545
New London, Conn.

This landscape was just inside the entrance to the Connecticut College Arboretum, located on Williams Street. The arboretum came to fruition in the late 1920s and boasts over 700 acres of wetlands, meadows, and forests—all available to the public and featuring self-guided tours. Connecticut College is located between Mohegan Avenue (Route 32) and Williams Street.

122

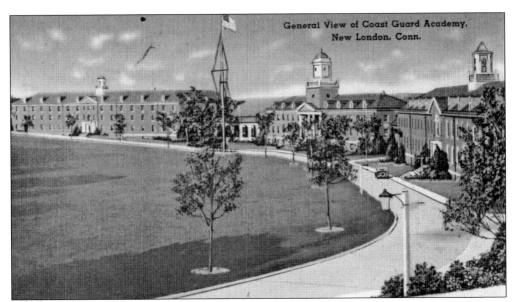

The US Coast Guard Academy, a four-year coeducational military college, faces Mohegan Avenue (Route 32). The Coast Guard purchased the land, on the west bank of the Thames River, in the early 20th century. Construction began on the Georgian-style red brick buildings, and the cadets relocated from Fort Trumbull in 1932. In the 1940s, women went through a two-month officer training program; in the 1950s, athletics expanded, land was acquired from Riverside Park, and the chapel was completed.

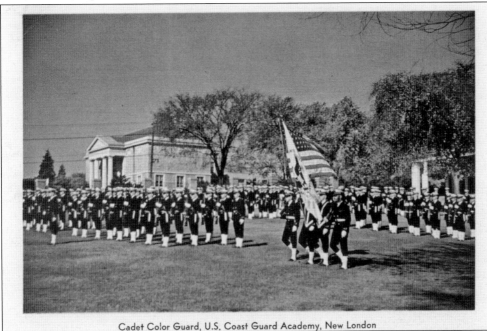

US Coast Guard cadets march on the parade ground alongside Route 32. In the background is the Lyman Allyn Art Museum at 625 Williams Street. The Neoclassical museum, designed by Charles A. Platt, was founded in 1932 by Harriet Upson Allyn in memory of her father, Lyman Allyn.

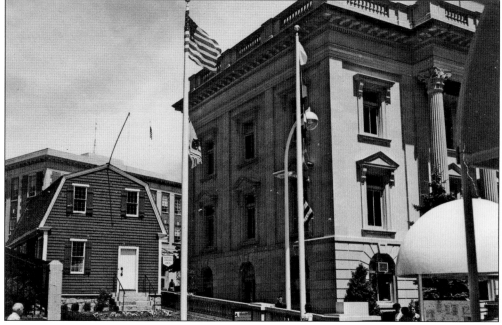

The Nathan Hale Schoolhouse (far left) is shown here when it was located next to City Hall blocking Union Street. From 1973 until 1990, State Street was closed to vehicular traffic and was known as Captain's Walk. The post office is visible behind the schoolhouse. The lower right corner of the image shows one of the many open kiosks that lined Captain's Walk. (Photograph for this postcard by Rick Gipstein.)

By 1998, the Nathan Hale Schoolhouse was moved from Union Street to the Parade just north of the Soldiers and Sailors Monument as shown in this picture. In 2012, the schoolhouse was moved an additional 50 feet north on Atlantic Street. (Photograph by Lawrence Keating.)

Nine

STATUES

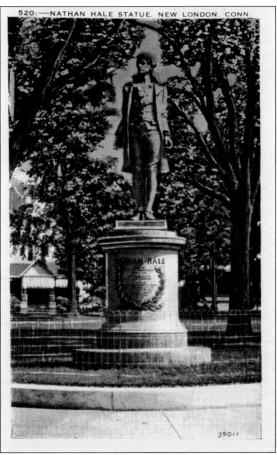

520:—NATHAN HALE STATUE, NEW LONDON, CONN.

The Nathan Hale statue is located in Williams Park at Broad and Williams Streets. It was unveiled on June 6, 1935, on the 180th anniversary of Hale's birth. The figure is a replica of the Nathan Hale statue that stands in City Hall Park in New York City. The bronze monument stands on a granite base. Around the top of the base is Hale's famous quote: "I only regret that I have but one life to lose for my country." Hale was a captain in the Continental army and a schoolmaster in New London.

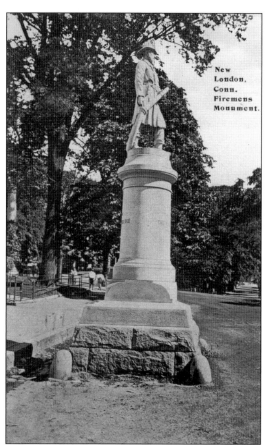

The Firemen's Monument stands in front of the State of Connecticut Superior Court. It was a gift from Sebastian D. Lawrence, a wealthy 19th-century merchant, and was dedicated on July 4, 1898, with an inscription reading: "A tribute to the memory of brave firemen." In 1920, this statue was relocated to the Grove Street entrance at Riverside Park, where it stood for many years. Today, it is located at the W.B. Thomas Hose & Northwest Fire Companies at Broad Street and Connecticut Avenue.

This postcard shows the fountain at Hodges Square on Williams Street. The horse trough provided animals with a place to have a drink when they went through the Hodges Square area. Mary Turner Allyn Henry gifted the fountain to the city in 1907 in memory of her father, Lyman, and her brother, John. The fountain was removed from Hodges Square during the expansion of the Gold Star Memorial Bridge and placed into the care of the Lyman Allyn Art Museum.

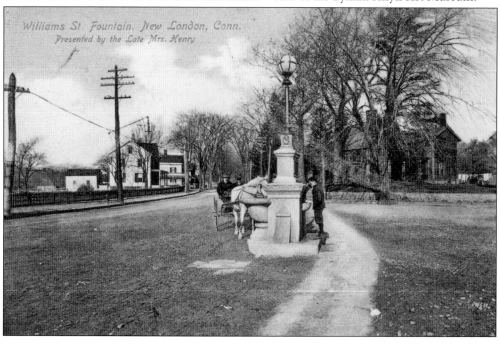

The Christopher Columbus statue, sculpted by Armand Battelli, is located in a small park—now referred to as Columbus Square or Columbus Circle—at the intersection of Blinman, Howard, and Bank Streets. The statue was donated to the city by Italian Americans on October 12, 1928. The marble statue stands on a granite base with the inscription "Colombo."

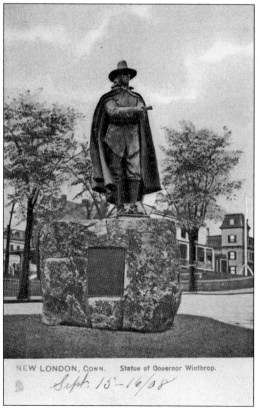

This statue of John Winthrop, Jr. stands at Bulkeley Place. Winthrop, the founder of New London, twice served as governor of the Connecticut Colony. The statue was sculpted by Bela L. Pratt, a native of Norwich, Connecticut, and dedicated on May 5, 1905. The homes in the background are located in the Post Hill Historic District.

DISCOVER THOUSANDS OF LOCAL HISTORY BOOKS FEATURING MILLIONS OF VINTAGE IMAGES

Arcadia Publishing, the leading local history publisher in the United States, is committed to making history accessible and meaningful through publishing books that celebrate and preserve the heritage of America's people and places.

Find more books like this at
www.arcadiapublishing.com

Search for your hometown history, your old stomping grounds, and even your favorite sports team.